The Kyoto Costume Institute

FASHION

From the 18th to the 20th Century

TASCHEN

HONG KONG KÖLN LONDON LOS ANGELES MADRID PARIS TOKYO

Contents

Foreword

Dedication to all people who wear clothing

This book consists of items of clothing selected from the extensive collections at the Kyoto Costume Institute (KCI). Since its inception in 1978, the KCI has held exhibitions around the world as a way of organizing research on Western fashion. The exhibitions and the catalogues that have accompanied them have met with acclaim from international audiences and by cutting-edge designers from all over the world.

Part of the recognition the KCI has received stems from its policy of displaying articles of clothing in a manner that is both academically accurate and true to life. In other words, the KCI presents clothing not just as historical artifacts, but also as vital elements of fashion. The exhibitions capture the elegance and charm that the clothing had in its day, as though simply having been "awakened" after a long "sleep." The KCI hopes that this publication, which covers selected historical clothing and fashion accessories from the eighteenth to the twentieth century, will enable an ever-wider audience to appreciate the wonder and pleasure of fashion.

How will fashion evolve in the twenty-first century? In the late nineteenth century, few people believed that women would ever be freed from corsets or that one day they would wear skirts revealing their thighs. It is therefore easy to imagine that surprisingly new and innovative ways of dressing will be enjoyed in the near future. The future transformation of fashion might be glimpsed by achieving an overview of the past history of fashion within its historical context.

The Kyoto Costume Institute aims to reassess our past through the study of Western fashion, examine the relationship between fashion and clothing, study the essential meaning behind the wearing of clothes, and suggest the direction that clothing will take in the future. The KCI believes that now, as ever, clothing is an essential manifestation of our very being.

This book presents the beauty and skill involved in the craftsmanship of fabric production and clothing design with high-quality images by excellent photographers. It is the goal of the Kyoto Costume Institute that this collection will be enjoyed as a common heritage shared by all peoples of the world.

Akiko Fukai, Chief Curator, The Kyoto Costume Institute

18th Century

With the death of Louis XIV and the coronation of Louis XV in 1715, a smart and refined style called "rococo" had blossomed. Though the term *rococo* was later used in the nineteenth century in a derogatory sense, suggesting excess and frivolity, today it refers to a general artistic style emblematic of harmonious French culture. The culture responsible for the rococo style was characterized by the pursuit of personal pleasure. Since that pursuit naturally included clothing, it, too, was soon elevated to the realm of art. Though France was already an acknowledged leader of fashion during the reign of Louis XIV, the rococo period confirmed the country's reputation as the leader of women's fashion worldwide. After the initial popularity of rococo, clothing styles veered off in two diametrically opposed fashion directions, one involving a fantastic conceit of artificial aesthetics, and the other a desire to return to nature. The French Revolution in 1789 modernized many aspects of society and brought a clear shift in clothing styles from decorative rococo to the more simple dress of neoclassicism. This radical change in clothing styles, a phenomenon unique in the history of fashion, is a reflection of the momentous upheavals in the social values of the period.

Women's Rococo Fashion

For women, the essential spirit of rococo fashion was rooted in elegance, refinement, and decoration, but there were also elements of capriciousness, extravagance, and coquetry. In contrast to the dignified solemnity of seventeenth-century costume, women's dress of the eighteenth century was both ornate and sophisticated. Men's costume in the seventeenth century had been more extravagant and colorful than women's, but women now seized the initiative and their court costumes became splendidly elegant. At the same time people also sought a comfortable lifestyle, one in which they could spend leisurely hours in cozy sitting rooms, surrounded by knickknacks and their favorite furniture. To accommodate these more down-to-earth urges, a relatively relaxed and informal style of dress also appeared. A new style in the early eighteenth century was the *robe volante*, or the flowing gown, derived from the négligé popular toward the end of Louis XIV's reign. The characteristic feature of the gown was a bodice with large pleats flowing from the shoulders to the ground over a round petticoat. Although the bodice was tightly molded by a corset, the loose-fitting pleated robe gave a comfortable and relaxed impression. Following the *robe volante*, the typical women's rococo gown was called the *robe à la française*, and this style was worn as formal court dress up until the Revolutionary period. Throughout the period, the basic elements of a woman's costume consisted of a robe, a petticoat much like what we would call a skirt today, and a triangular stomacher worn over the chest and stomach under the front opening of the robe. These garments were worn over a corset and a pannier, both of which formed the body silhouette. (The term *corset* was not used in the eighteenth century, but is used here to refer to an undergarment stiffened with whalebone stays, called *corps*, or *corps à baleine*.) With only the decorative details changing decade after decade, such were the fundamental components of women's dresses until the French Revolution. Painters such as Jean-Antoine Watteau, Nicolas Lancret, and Jean-François de Troy portrayed these splendid dresses in great detail, depicting everything from individual stitches of lace down to intricate footwear. In *Gersaint's Shopsign* (1720, Schloss Charlottenburg, Berlin), Watteau dramatically

delineated the elegant gowns of the day and the delicate movement of their pleats, and captured their lustrous, smooth textures of satin and silk. Although he himself did not design them, such double-folded pleats at the back later became known as "Watteau pleats." Extravagant silk fabrics produced in Lyons, France, were essential for rococo fashion. From the seventeenth century onwards, the French government supported the diversification of silk fabric production in Lyons through the development of new loom mechanisms and dyeing technology. French silk fabrics gained a reputation for top quality, and replaced the Italian silk products that had been dominant during the previous century. In the mid-eighteenth century, the golden age of rococo, Louis XV's mistress Madame de Pompadour appeared in portraits wearing exquisite gowns made from silk fabrics of the highest quality. In the François Boucher portrait *Madame de Pompadour* (1759, The Wallace Collection, London; ill. p. 18), she wears a typical *robe à la française*, the gown opening at the front over a tightly fitted bodice. A petticoat and triangular stomacher can be seen under the robe. The stomacher is richly decorated with a ladder of ribbons (*échelle*), which accentuates the shape of her bosom, which is seductively lifted and formed by the corset. In addition, *engageantes* of top-quality lace adorn the cuffs of the dress. Flounces, lace, ribbons, and artificial flowers embellish the entire robe. Although the ornamentation might be said to be excessive, the elements harmonize well and present the most sophisticated and delicate spirit of rococo. During the same period that rococo reached such decorative heights, the aristocracy found itself turning toward the fashion of the commoners for hints on how to dress for a more comfortable lifestyle. The functional coats and skirts of ordinary people influenced aristocratic women's costumes, which gradually tended toward simpler styles, except on formal occasions. A practical short coat called a *casaquin* or a *caraco* was adopted for everyday wear, and robes were simplified. The stomacher, for example, once attached to the robe with pins, was now replaced by the relative ease of two flaps of fabric (*compères*) that connected the front opening of the robe. The growing popularity of simpler, more functional dresses in France at the time was in part due to "Anglomania," a fascination with all things English prevalent at the time in French culture. The first signs of Anglomania in men's costume can be found in the final years of the reign of Louis XIV, and then in women's costumes after 1770. When the English custom of walking in the countryside and enjoying the open air became popular among the French, the *robe retroussée dans les poches* appeared as a fashionable style for women. The skirts were pulled through the slits for the pockets in the side of the dress and draped over the back in a practical arrangement originally created for working-class women to wear while at work or walking through the town. This fashion was succeeded by the robe *à la polonaise*. In this style, the back of the skirt was held up by strings and divided into three draping parts. Poland was divided (first) by three kingdoms in 1772, and it is said that the term robe *à la polonaise* derives from this political event. When the pleats at the back center of the robe were sewn down all the way to the waist, the style was called *robe à l'anglaise*, or English style. A *robe à l'anglaise* consisted of a front-closing robe and a petticoat that protrudes from under the rear bodice, which has a pointed shape at the lower end. Sometimes the robe was worn without a pannier, attaining its round shape solely through the drapes of the skirt. Later, during the Revolutionary period, the trend incorp-orated the stomacher and skirt, and was transformed into a one-piece dress, or round gown.

Elegance in Men's Fashion

During the seventeenth century, new, colorful, and ornate men's costumes constantly appeared, but in the eighteenth century, men's fashion was more stable and less garish. The *habit à la française*, a typical eight-eenth-century French suit, consisted of a coat (*habit*, called *justaucorps* in the seventeenth century) which gradually became fitted in shape, a waistcoat, and breeches. A white shirt, a jabot frill, a cravat, and a pair of

silk stockings completed the men's suit. Brilliant colors, intricate embroidery, decorative buttons, and elaborate jabots for the neck, chest, and cuffs were the important elements for gentlemen dressed in the rococo style. In particular, the coat and waistcoats of the typical suit (the *habit à la française*) were elaborately embroidered with gold, silver, and multicolored threads, sequins, and artificial jewels. Many embroidery workshops were located in Paris during this period. Cloth for jackets or waistcoats was often embroidered before tailoring so that men could first choose their favorite patterns, then order the suit cut and sewn to size. Anglomania, evident in French men's costumes from the late seventeenth century, continued to be in fashion. For example, the collared English riding-coat (*redingote*) was adopted for town wear as an alternative to the French coat. During the latter half of the eighteenth century, the French version of the English frock coat, or *frac*, appeared. This was a jacket with a turned down collar, generally constructed from a plain-colored fabric. On the eve of the Revolution, striped patterns became popular, and the passion for elaborate embroidery on men's suits disappeared. Due to the English taste for simplicity, the *frac* continued to be a standard item of men's clothing throughout the nineteenth century, along with the pantaloons that eventually replaced breeches.

Exoticism: Chinoiserie and Indienne

Europeans had long been intensely curious about various items imported from the East. In the seventeenth century, the importation of remarkable Chinese decorative arts brought a new form of exoticism and created a vogue for *chinoiserie*. Complex, curvaceous forms based on Oriental aesthetics and sensibility inspired painters such as Jean-Antoine Watteau and François Boucher, who were fascinated by exotic Chinese scenery and customs. In aristocratic residences, the sitting room was often decorated with rare Chinese furniture and porcelain, and in the garden it was not uncommon to find a small arbor and a pagoda. Dress also reflected a Chinese influence. In particular, textiles with asymmetrical patterns and unusual color combinations found popularity at the time. The desire for exotic cultural details and variety stimulated an interest in Bizarre silks, *ungen* embroidery, Pekin stripes, and in Nankeen (yellow cotton from Nanking, China). Even the names of these materials evoke an exoticism valued by late rococo culture. As accessories, oriental folding fans, which had been important accessories in European fashion since the sixteenth century, were now called upon to complete the *chinoiserie* ensemble. Europeans did not accord Japan a distinct national cultural identity until the latter half of the nineteenth century, when the "Japonism" movement took off in Europe. However, as early as the seventeenth and eight-eenth centuries, Japanese kimonos were imported by the Dutch East India Company and worn by European men as an indoor gown. Since the supply of authentic imported Japanese kimonos was limited, oriental gowns made of *indienne* (Indian chintz) appeared to help satisfy the demand. These were called *Japonsche rocken* in Holland, *robes de chambre d'indienne* in France, and banyans in England. Due to their exotic features and relative rarity, they became status symbols of wealth. The *indienne*, a painted or printed cotton fabric made in India, became so excessively popular among Europeans during the seventeenth century that authorities felt compelled to ban the import and production of *indienne* until 1759. Once the ban was lifted the printing industry immediately grew. Among many printed fabrics, the Jouy print became especially well known. Christophe P. Oberkampf, who set up the Jouy factory in the Versailles suburb of that name, profited from timely developments in both physics and chemistry. Through technical innovation, he invented a new printing technique in place of the conventional resist-dyeing method, and adopted advanced printing techniques from England. Printed cotton fabrics became the trend not only for clothing, but also for interior decoration; their exotic and refined multi-colored patterns were appealing, and they were priced more economically than silk fabrics. Printing factories sprang up all over

Europe in the eighteenth century. Initially merely imitating *indiennes*, these factories inspired technical developments such as the invention of the copper roller printing system, which made possible the mass production of printed fabrics. The popularity of cotton fabrics during this time helped give rise to the shift in favored material for clothing from silk to cotton during the Revolutionary period.

The Fantastical Aesthetics of Artifice and the Return to Nature

As the *ancien régime* teetered on the verge of collapse, the fully-matured rococo style waned in importance. In the 1770s, the typical women's court costume was a huge skirt pushed out on both sides with a wide pannier, and a high coiffure whose aim was to exalt the beauties of artifice. Women's dresses were not so much items of apparel as awesome architectural constructions made of fabric. The refined aesthetics of rococo culture disappeared, and its delicate lightness was replaced with the looming shadows of the Revolution. The gigantic coiffures, huge wigs, and outrageous headdresses of this period amplified the darkness of those looming shadows. Women's faces looked tiny framed in the center of such outlandish ornamentation. Coiffures were often large enough to contain models of chariots, landscapes, streams, fruit baskets, and all sorts of other fanciful elements. In order to dress in a stylish fashion, *coiffeurs* (hairdressers) were required to lay out, construct, and arrange the extraordinary hairstyles. To match the hair, the creation of extravagant decorations for dresses was also essential. A vital method for spreading the trends of Paris was (as it still is) the fashion magazine. Although one periodical that introduced the latest fashions in Paris had already emerged during the seventeenth century, several new and important fashion magazines sprang up in the pre-Revolutionary period. These included *Le Journal du Goût* (1768–1770), *Le Cabinet des Modes* (1785–1786), and *La Galerie des Modes et du Costume Français* (1778–1788), all of which appeared during the second half of the eighteenth century. In the latter part of the nineteenth century, with the help of advanced printing technology and the development of railroad delivery systems, fashion magazines became still more important sources for trend-setters and a way for the arbiters of Paris fashion to disseminate their creations. In marked contrast to the extravagance of court costumes, ordinary clothing tended to be simple and comfortable. The excavation of the ancient Roman ruins of Herculaneum in 1738 provided the impetus for an emerging style of neoclassicism based on a worship of antiquity. Incorporating the concept of Jean-Jacques Rousseau's "return to nature," this attention to ancient Greece and Rome became an essential theme in the changing ideals of European society. It was a theme, that came to dominate the arts and general lifestyle of Europeans from the second half of the eighteenth century until the early nineteenth century. A forerunner of the clothing style that would reflect this theme, a style influenced by Anglomania, was one adopted by Marie-Antoinette. To escape the rigors of court life, the young queen took to dressing in a simple cotton dress and a big straw hat, and played at being a shepherdess at the Hameau de la Reine at the Petit Trianon in Versailles. It is not surprising then that the queen also favored a simple, white muslin chemise, a style that around 1775 came to be known as the *chemise à la reine*. In terms of its material and its construction, the *chemise à la reine* served as a transitional form to the high-waisted dress of the Directory period.

The Corset and the Pannier

Throughout the eighteenth century, the outline of a woman's dress was formed by undergarments, such as the corset and the pannier. In the age of rococo, the top of the corset was dropped down to a position that made the breasts partially visible. The corset no longer restrained the entire bodice area, but rather pushed

up a bust that peeked through a delicate fringe of lace at the neckline of the dress. The early form of the pannier was bell shaped, but as skirts widened in the mid-eighteenth century, the pannier was modified and split into left and right halves. Although the huge and impractical pannier that resulted was frequently the subject of caricature, women simply adored the fashion. At court, the wide pannier eventually became a compulsory element of attire. Complex garments such as these were usually manufactured by men. A guild of tailors had been established during the medieval period in France, and, from that time on, each role in the construction of clothing was strictly regulated. Although a company of female dressmakers, *Les Maîtresses Couturières*, had been established in the second half of the seventeenth century to make women's clothing, male tailors generally sewed all eighteenth-century court costumes. Men also made women's corsets, as strong hands were needed to stitch whalebone into stiff corset material.

Fashion in the Revolutionary Period

In 1789, the French Revolution promoted a profound change in the aesthetics of fashion, and the favored fabric shifted from refined silk to simple cotton. It was a revolution with many causes: the failure of the national economy, increased conflict between the aristocracy and those with royal prerogative, the discontent of a majority of citizens toward the more privileged classes, and an extended, severe food shortage. The Revolution adopted fashion for the purposes of ideological propaganda in the new age, and revolutionaries declared their rebellious spirit by appropriating the clothing of the lower classes. Those who still wore extravagant and brightly colored silk clothing were considered anti-revolutionary. Instead of the knee breeches and silk stockings that symbolized the nobility, revolutionaries wore long pants called *sans-culottes* (non-breeches). Besides his long pants, the revolutionary sympathizer dressed in a jacket called a *carmagnole*, a Phrygian cap, a tricolor cockade, and clogs. Derived from simple English tastes, this fashion evolved into a style of frock coat and trousers, which was afterward worn by the modern citizen in the nineteenth century. But not everything changed in 1789. During the Revolution, new fashion styles emerged in quick succession, reflecting the changing political situation, but conventional clothing, such as the *habit à la française*, was still worn as the official court costume. New and old fashions intermingled during the Revolutionary period. In some cases the chaotic social climate created eccentric fashions. In particular, the youth of France embraced unusual, frivolous, and radical styles. During the Terror, the *Muscadins*, a group of young counter-revolutionaries, protested against the new order, and dressed in eccentric black coats with large lapels and wide cravats. In a similarly eccentric vein, fops (*petits-maîtres*), called *Incroyables*, appeared during the Directory period. Extremely high collars characterized their fashions, with large lapels folded back, gaudy waistcoats, wide cravats, breeches, cropped hairstyles, and bicorne instead of tricorne hats. Their female counterparts, who were known as the *Merveilleuses* (the marvelous ones), wore extremely thin and diaphanous dresses with neither corset nor pannier. Illustrations of round gowns, dresses with waistlines starting just below the bust, and a bodice and skirt made of one piece, can often be seen in the fashion plates of Nicolaus von Heideloff's *Gallery of Fashion* (1794–1802, London). The round gown later transformed into the chemise dress, the most popular cotton dress of the early nineteenth century. Whereas in England modernization was brought about by the Industrial Revolution, French society received new impulses in the late rococo period through political revolution. Set against the backdrop of such social unrest, European fashion moved toward a new modernity.

Tamami Suoh, Curator, The Kyoto Costume Institute

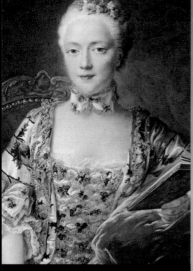

François-Hubert Drouais
La Marquise d'Aiguirandes (detail), 1759
The Cleveland Museum of Art, Cleveland

Stomacher
1760s, Swiss

White *bouillonné* silk satin decorated with polychrome silk, chenille threads and flowers of fly fringe.
Inv. AC4854 84-18-13

The *robe à la française*, a dress with a V-shaped opening in the front, was worn with a stomacher, a triangular panel with a V- or U-shaped bottom, which covered the front of the bodice. A small inner pocket was sometimes attached to the stomacher. To keep the bosom from standing out, the stomacher was extravagantly adorned with embroidery, laces, rows of neatly arranged ribbon bows called an *échelle* (ladder), and sometimes jewelry. Since stomachers needed to be pinned to the dress each time they were worn, this style was time-consuming to wear.

Page 14
Dress (robe à la française)
Mid-1760s, English

Pink silk satin with self-fabric decoration; triple-flounced pagoda sleeves; matching stomacher and petticoat.
Inv. AC4788 84-5-1AB

12

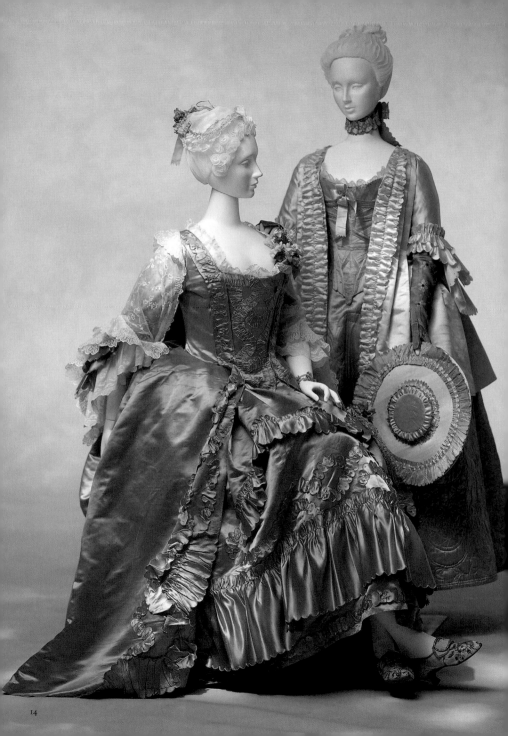

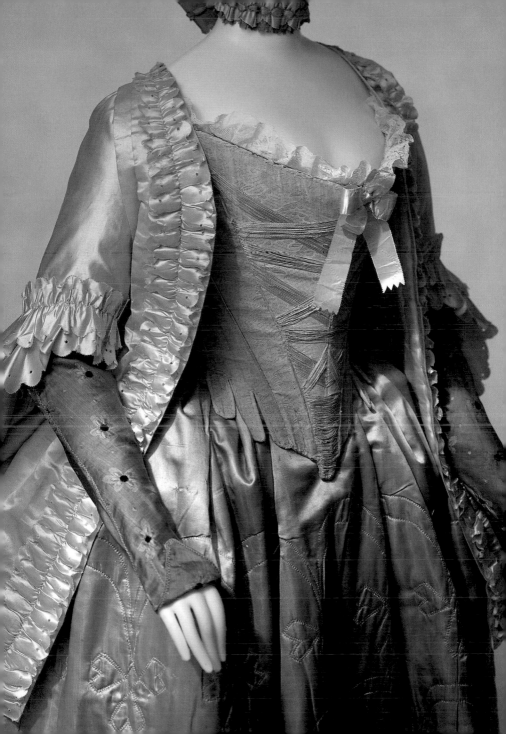

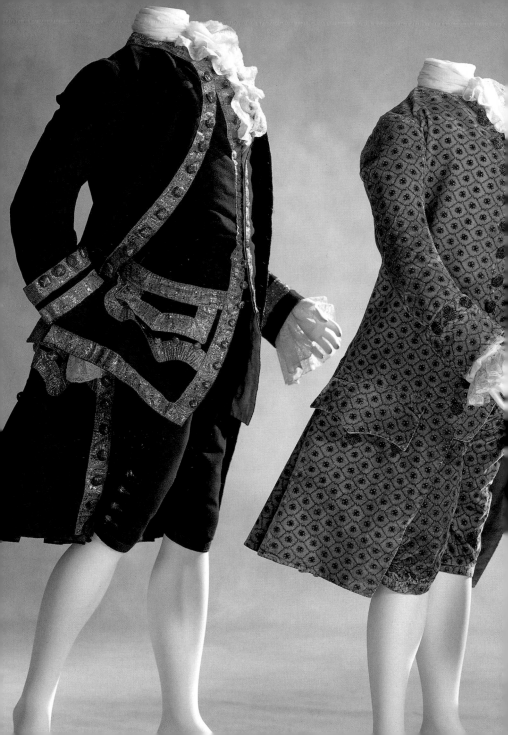

Page 15
Jacket (pet-en-l'air) and Petticoat
Late 1760s

Silk satin jacket with double-flounced pagoda sleeves, self-fabric decoration; corset of silk damask decorated with bundled silk threads; petticoat of quilted silk satin; mitts of silk brocade (French).
Inv. AC5391 86-26-3, AC27 77-5-16

Although extravagant men's wardrobes were prominent in the seventeenth century, those of the eighteenth century became more subtle and refined. The seventeenth-century men's jacket, the *justaucorps,* was replaced in the second half of the eighteenth century by the *habit* (coat), which was worn with a waistcoat and knee-breeches.

Left
Man's Suit (coat, waistcoat, and breeches)
c. 1740
English

Wine-red wool; coat and waistcoat decorated with gold braid and buttons wrapped with gold threads; sleeved waistcoat; jabot of Valenciennes lace; sleeve ruffles of Binche lace.
Inv. AC5507 86-51-3AC

Center
Man's Suit (coat, waistcoat, and breeches)
c. 1765
French

Deep-yellow velvet woven with small floral figures and cartouches; buttons wrapped with silver threads; sleeveless waistcoat; jabot and sleeve ruffles of bobbin lace.
Inv. AC306 77-12-21AC

Right
Man's Suit (coat, waistcoat, and breeches)
c. 1760

Purple suit of silk brocade with double-leaf motif; wide folded-back cuffs; waistcoat with sleeves in different fabrics; jabot and sleeve ruffles of Brussels appliquéd lace with floral patterns.
Inv. AC878 78-24-53AC

17

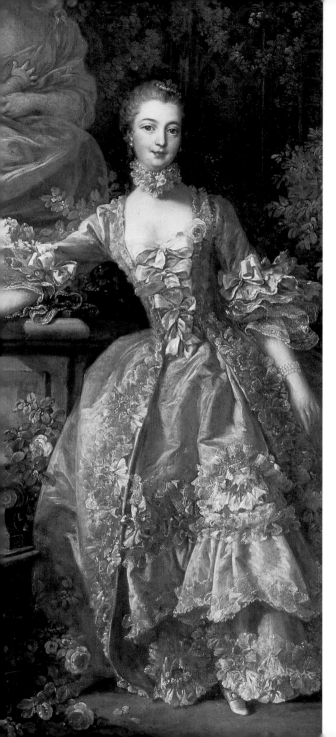

The fabric with the water-blotting pattern was called *chiné à la branche* in French. Just as in the Japanese *hogushi*-weaving (a type of *kasuri* technique), the pattern was printed onto the warp prior to weaving. In Europe, the *chiné* technique was extremely difficult, so the large *chiné* patterns were produced only in France. The patterns were mainly applied on thin fabrics such as silk taffeta. Light pastel coloring and fluffy texture are characteristic of *chiné*. During the mid-eighteenth century, it was fashionable to use *chiné* for high-priced summer clothing. Since Madame de Pompadour strongly preferred wearing dresses of *chiné*, it was often called "Pompadour taffeta."

→ **Dress (robe à la française)**
c. 1765
French

Light-blue Lyons silk *chiné* with cartouche-enclosed floral motif; self-fabric trim; double-flounced cuffs; matching stomacher and petticoat; engageantes of Alençon lace; lappets and bonnet of Argentan lace.
Inv. AC5317 86-8-5AE

← **François Boucher**
Madame de Pompadour (detail), 1759
The Wallace Collection, London

Pages 20/21
Dresses (robes à la française)
c. 1770–1775
French

Left: Yellow Lyons brocade with white floral stripe; *compères* with buttons; double-flounced pagoda sleeves; matching petticoat.
Inv. AC14 77-5-7AB

Center: Blue Lyons silk *cannelé* with stripe and floral ribbon motif; *compères* with buttons; double-flounced pagoda sleeves; matching petticoat.
Inv. AC5054 84-40AB

Right: Pink Lyons brocade with stripe and floral pattern, self-fabric and fly fringe trim; single-flounced pagoda sleeves; matching petticoat.
Inv. AC4241 82-13-1AB

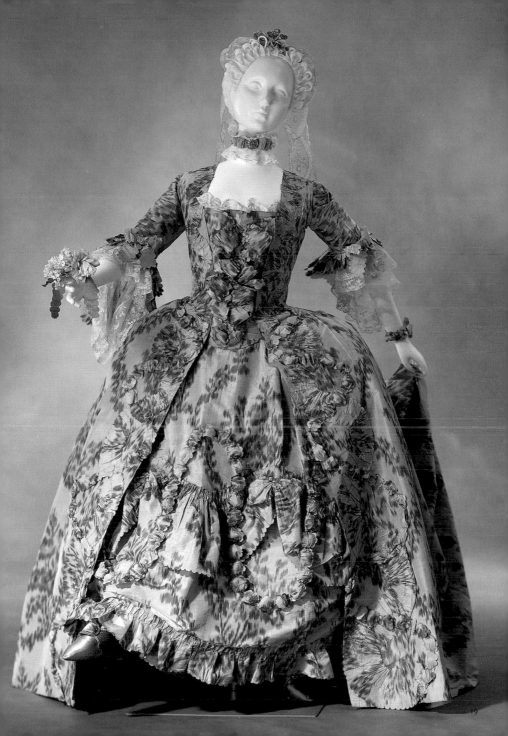

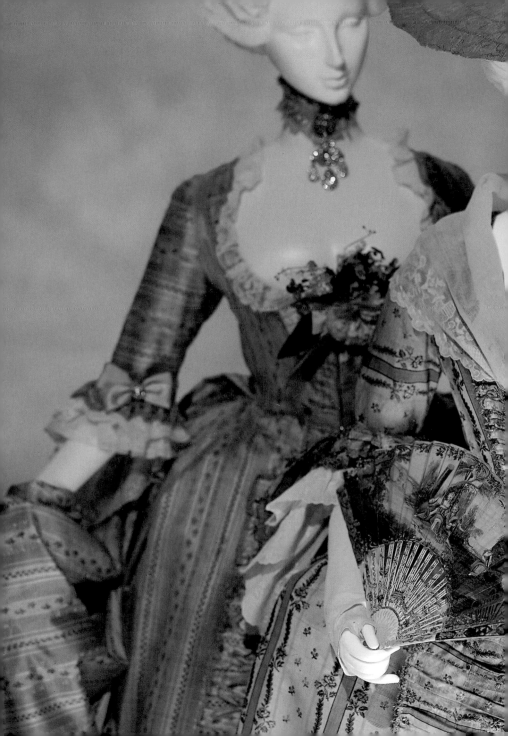

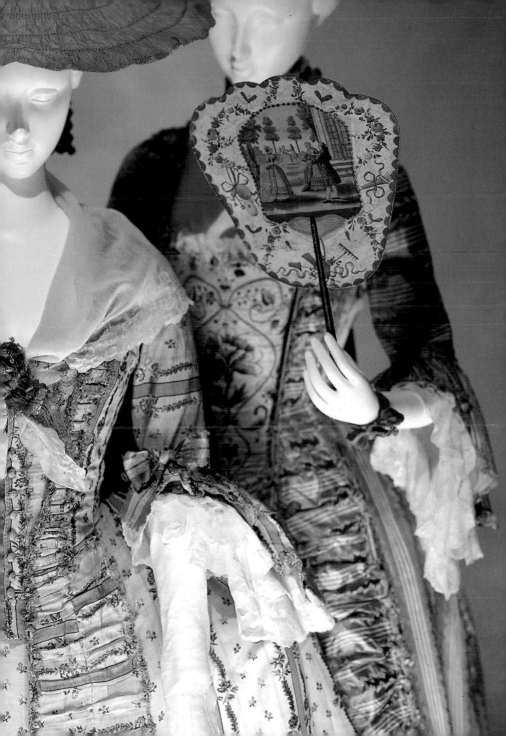

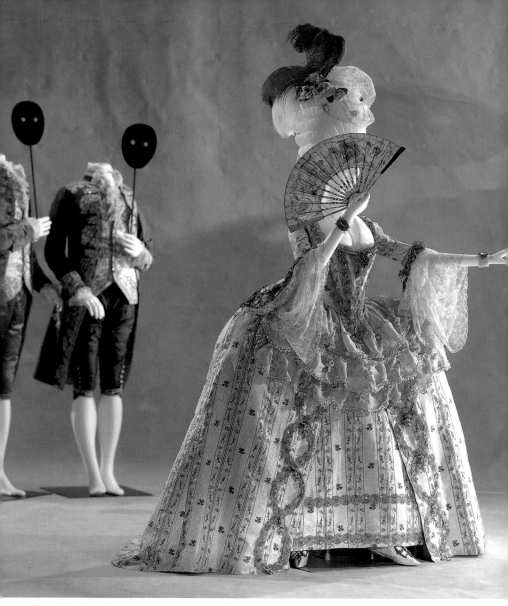

The typical eighteenth-century French suit, the *habit à la française*, consisted of a coat, a waistcoat, and breeches. It also included a pair of silk stockings, a jabot, a linen or cotton shirt with decorative cuffs, and a cravat. Men's suits transformed to a more functional style in the last half of the eighteenth century. Overall the coat became tight-fitting, the length of the waistcoat became short, the waistcoat's sleeves were removed, and the hem was cut horizontally. Yet the brilliant colors, exquisite embroideries, elaborate lace for jabots and cuffs, and decorative buttons still remained important elements for dressing a gentleman in the rococo style.

↖ **Dress (robe à la française)**
c. 1775
English

White striped floral Spitalfields silk *cannelé* with metallic
lace trim; double-layered pagoda sleeves; triple-layered
engageantes in Brussels lace; silk gauze apron with fly fringe
and chenille decoration.
Inv. AC4687 83-29-3AB

↑ **Man's Suit (habit à la française)**
c. 1770–1780s
French

Set of coat, waistcoat, and breeches of pale blue striped silk
taffeta with woven floral trim; sleeve ruffles in needlepoint
lace.
Inv. AC3861 81-18-1AC

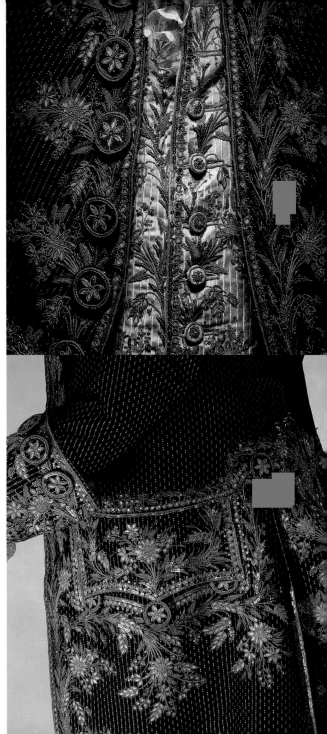

Illustration of men's buttons
Magasin des Modes, June 10, 1788

Man's Suit (habit à la française)
c. 1790

Three-piece set of coat, breeches, and
breeches; coat and waistcoat of blue
striped uncut velvet with sequins and
glass jewels; embroidery of metallic
thread, self-fabric-wrapped buttons;
waistcoat of white figured silk.

Inv. AC985 78-29-1AC

24

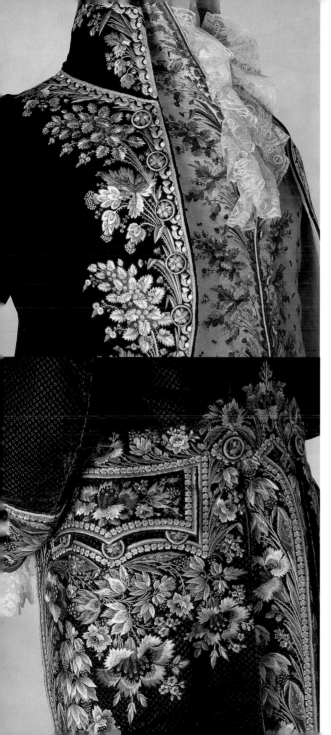

← **Man's Suit (habit à la française)**
c. 1810
French

Three-piece set of coat, waistcoat, and breeches; coat and breeches of black wool broadcloth with colored-thread embroidery; high standing collar; self-fabric-wrapped buttons; waistcoat of white silk satin with polychrome embroidery.
Inv. AC12 77-5-5AC

↙ **Man's Suit (habit à la française)**
c. 1790
French

Coat and breeches of green cut velvet with polychrome floral silk embroidery; high standing collar; buttons wrapped with fabric.
Inv. AC3334 80-21-20AB

Pages 26/27
Functional clothing influenced by Anglo-mania came into French women's fashion in the 1770s. The *retroussée dans les poches* was a style popular for walking in the countryside and enjoying the open air. In this new style, the skirt was pulled out from side pockets of the dress and draped on the back. This style derived from the work clothes and town wear of ordinary people. Later, the style was transformed into the *robe à la polonaise*, with the skirt held up by cords.

Dress (robe retroussée dans les poches)
c. 1780
French

White and red-striped pekin silk faille with *moiré* effect; self-fabric and fly fringe; matching petticoat; fichu of cotton drawn work; lettercase of silk taffeta with floral embroidery trimmed with braid; silk satin high-heeled shoes.
Inv. AC5316 86-8-4AB

25

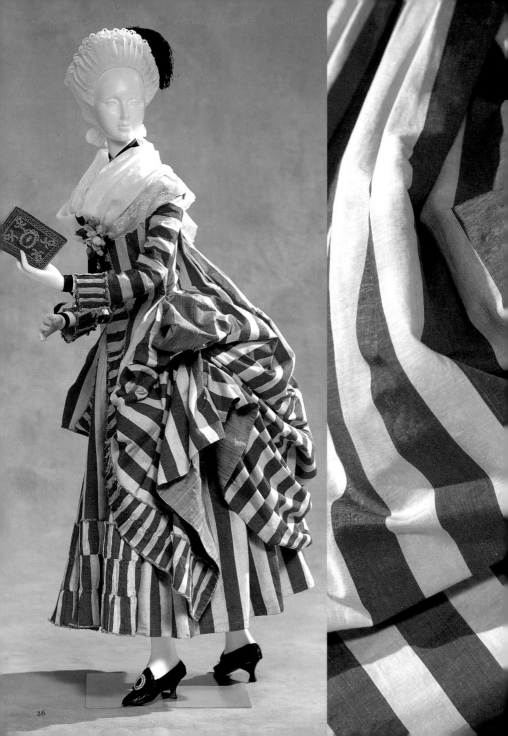

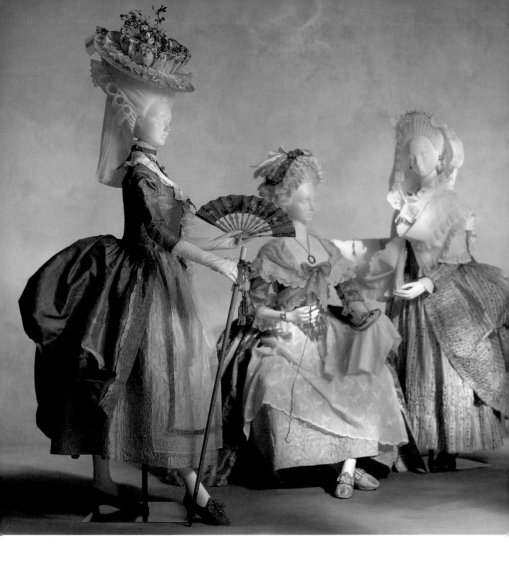

Dress (robe à la polonaise)
c. 1780
French

Green silk taffeta with oriental motifs;
five bones in the bodice back,
compères front; silk gauze and taffeta
trim; petticoat of quilted silk satin
(English).
Inv. AC4465 83-11-1AD

Dress (robe à l'anglaise)
c. 1780
English

Blue and white Spitalfields silk
damask with flower and stripe pat-
tern; sabot sleeves; *compère* front;
petticoat of quilted silk satin; fichu
and apron of muslin whitework.
Inv. AC2200 79-9-5

Dress (robe à la polonaise)
c. 1780
French

Pink and white striped cotton brocade
with Jouy floral print; self-fabric
shirring borders; matching petticoat;
hooded shawl of linen with pleated
trim.
Inv. AC5388 86-26-1AB

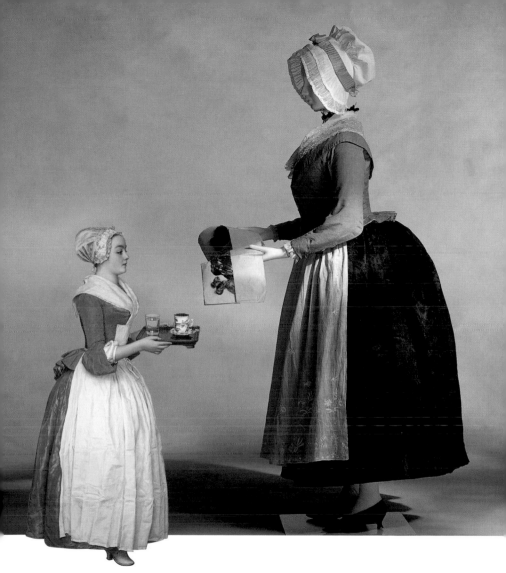

Jean-Etienne Liotard
La Belle Chocolatière (detail),
1744–1745 Gemäldegalerie
Alte Meister, Dresden

Following the trend toward simple
clothing, women's costumes became
less ornate (except for court fashion)
in the 1770s. Flowing pleats from the
center back of a dress were gathered to
the waistline, and such a dress was
called the *robe à l'anglaise*. The dress
consists of a front-closing robe and a
skirt attached to the back of the
bodice, without a pannier.

Jacket and Petticoat
c. 1780

Deep yellow silk *moiré* with shawl
collar; front fastened with buttons
(French); petticoat of black silk
damask; fichu and apron of muslin
whitework.
Inv. AC5785 88-19-14, AC5786 88-19-15

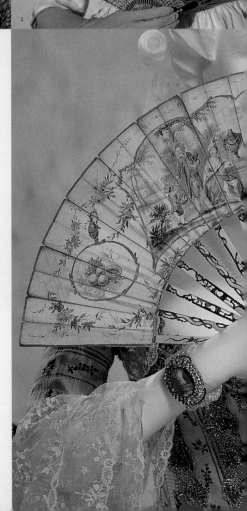

The folding fan originated in Japan.
After the Japanese folding fan made of
hinoki (Japanese cypress) was intro-
duced to China in the end of the
Heian period (the twelfth century),
the Chinese started to produce folding
fans of sandalwood or ivory with gold
and silver decorations. Oriental fans
were imported to Europe in the fif-
teenth and sixteenth centuries. It was
1549 when the folding fan first
appeared on the French court fashion
scene. In the seventeenth century, fan
production started in France, mainly
in Paris, and the popularity of French
fans reached its peak in the mid-eight-
eenth century. Representing the high-
est level of craftsmanship in the eight-
eenth century, elegant French fans
were made of various materials such as
tortoiseshell, ivory, and mother-of-
pearl, with applied lacquer painting
and engraving.

1. Fan
c. 1740–1750

Cartouches of hunting and everyday
scenes and flowers, wood pattern
hand-painted on ivory.
Inv. AC6333 89-17-5

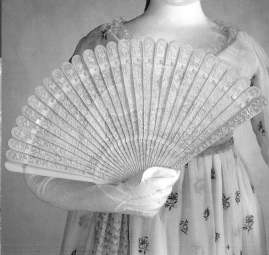

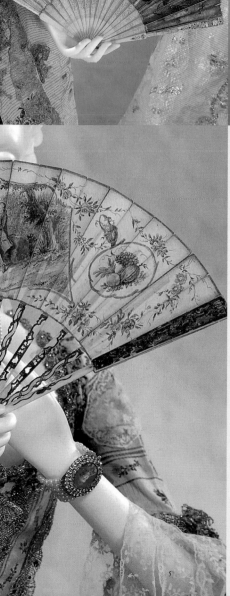

2. Fan
c. 1800
Chinese (?)

Grapevine and medallion motif with
hexagonal pattern, hand-painted in
brown and gold lacquer; vine pattern
also in three medallions; brisée.
Inv. AC2219 79-9-24

3. Fan
c. 1760
Dutch (?)

Two-colored leaf hand-painted with
ships, seashore scenery and fruit;
open-work ivory sticks.
Inv. AC1047 78-30-59

4. Fan
c. 1800
Chinese

Open-work ivory brisé.
Inv. AC1708 78-41-112

5. Fan
c. 1760–1770
Dutch

Leaf hand-painted with garden, fruit
and human figures; open-work ivory
sticks with silver and gold inlay.
Inv. AC5778 88-19-7

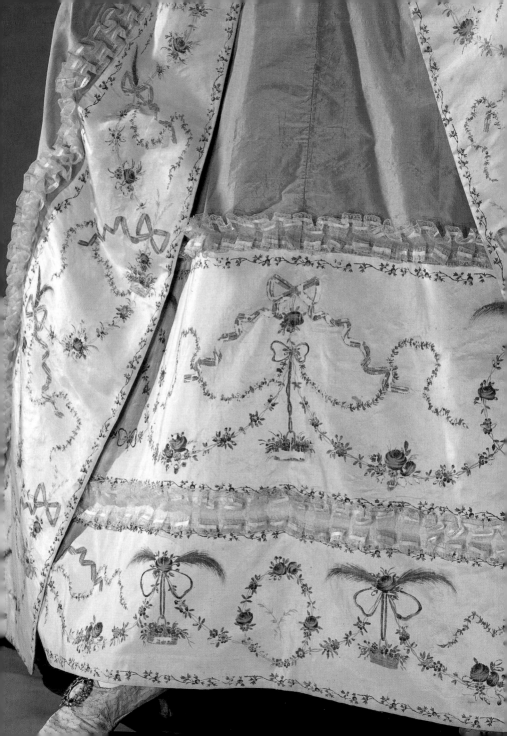

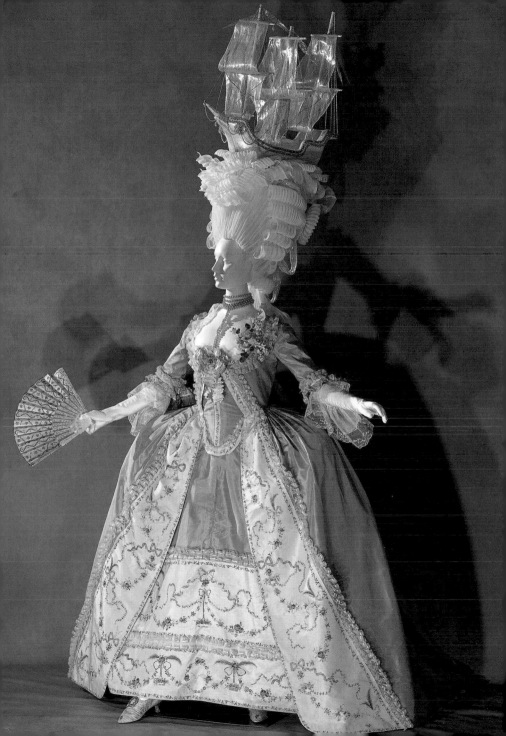

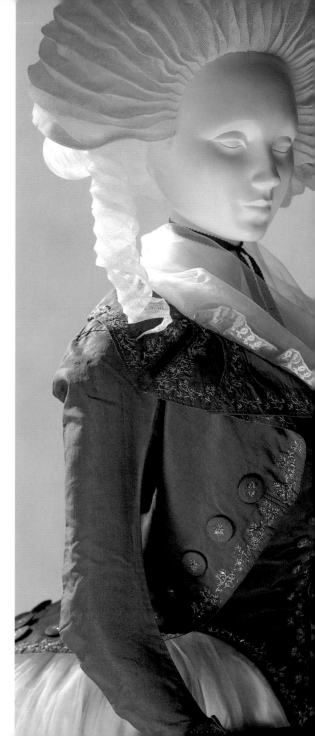

Pages 32/33

In the 1770s, women's court fashion was characterized by a huge skirt that was widely expanded on each side by a pannier, and a high coiffure. This fashion expressed the pinnacle of artificial beauty; it was as if women's dresses were architectural constructions made out of fabric. Enormously enlarged coiffures and wigs added more obscurity to the costume. The coiffures and wigs, which once looked like picturesque landscapes and flowerbeds, now became somewhat odd and extravagant. The 1778 victory of the French frigate *La Belle Poule* inspired new hairstyles such as the *à La Belle Poule*, the *à l'Indépendante*, and the *à La Junon*, in which scaled-down replicas of warships were put on top of the head. This became a trend at the time.

Dress (robe à la française)
c. 1780
French

Pink silk taffeta with painted garlands; matching stomacher and petticoat; engageantes of blonde lace.
Inv. AC5312 86-8-1AC

The English love of country life and enjoyment of hunting brought the redingote and the Hussarde-style jacket, originally clothing for men, into women's fashion. In the ensemble on the left, the button fasteners at the front of the *gilet* show the influence of men's clothing.

Left
Jacket and *Gilet*
c. 1790
French

Jacket of blue silk taffeta with floral embroidery of silk thread and sequins; button fastener at front of *gilet*; lacing closure at back.
Inv. AC4350 82-21-13AC

Right
Jacket
c. 1790
French

Pink silk taffeta; drawstring neckline; waist belt with lacing fastener; boned at center back.
Inv. AC5372 86-18-3

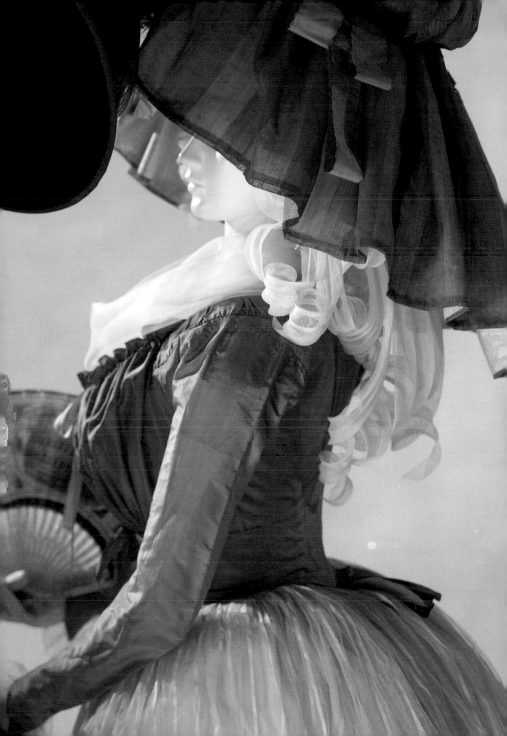

A draped thin fichu covered over the shoulder and neck, with both ends tucked into the stomacher and the bust to create an elegant pigeon-breasted silhouette; however, in the nineteenth century, the fichu was replaced in popularity by the larger shawl.

↓ **Buckle** (detail)
c. 1790
English

Medallion-shaped metal frame, and white porcelain with motif of two birds at center, laurel wreath, heart and arrow.
Inv. AC5782 88-19-11A

→ **Dress (robe à l'anglaise)**
c. 1790
English

Cream silk taffeta; two-layered *compères* front with buttons; matching trim; black lace decoration at front bodice and cuffs; wine-colored ribbon lacing at cuffs; matching petticoat; fichu at neck.
Inv. AC9228 95-19-2AB, EF

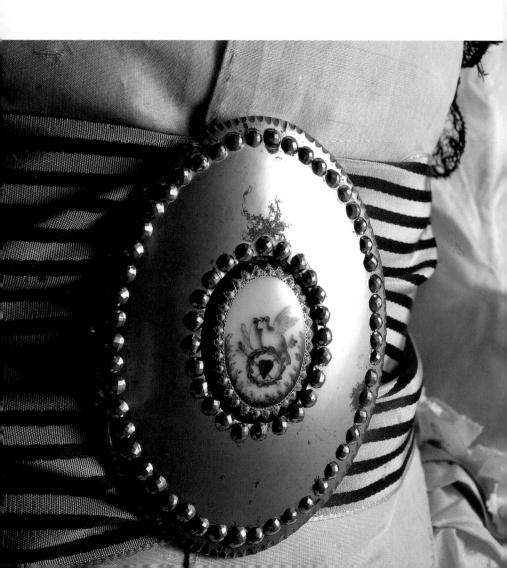

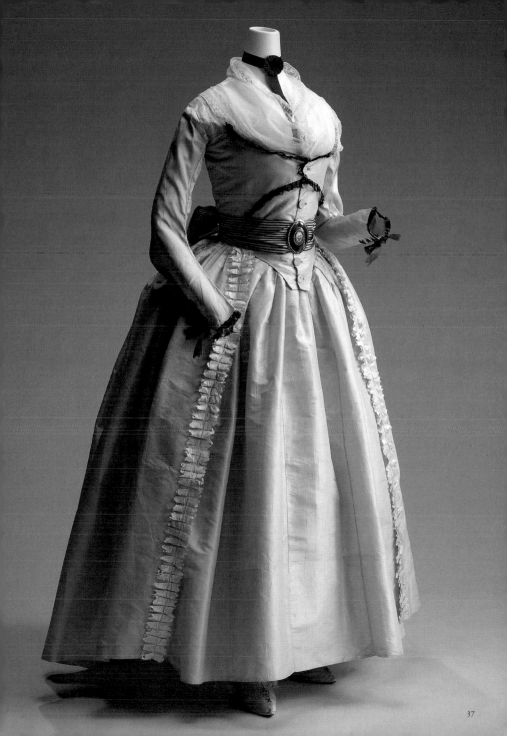

Left
Corset
c. 1785
English

Beige quilted silk taffeta; front lacing with hand-darned eye-
lets; boned at center front and back and both sides; straps tied
with ribbon.
Inv. AC4431 83-2-5

Center, above
Corset
c. 1785
English

Beige coutil with continuous straps; front lacing with hand-
darned eyelets; boned throughout; probably altered from a
mid-eighteenth-century corset.
Inv. AC5080 85-9-4

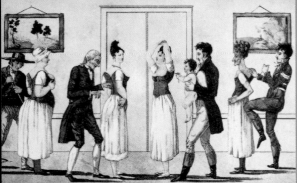

"The Fad for Corsets" from *Le Corset*, c. 1809

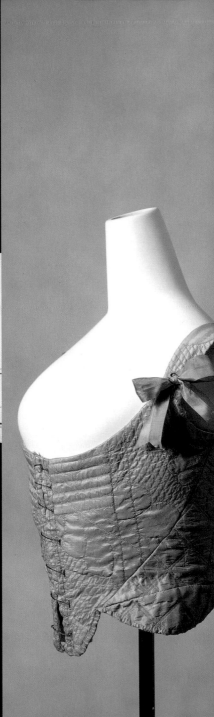

Center, below
Child's Corset
c. 1785
English

Beige plain-weave linen; boned throughout; back lacing.
Inv. AC6380 89-17-52

Right
Corset
c. 1790

White linen chintz; boned front, back and sides; metal
spring at sides to adjust; front lacing; straps tied with cord.
Inv. AC4197 82-5-5

38

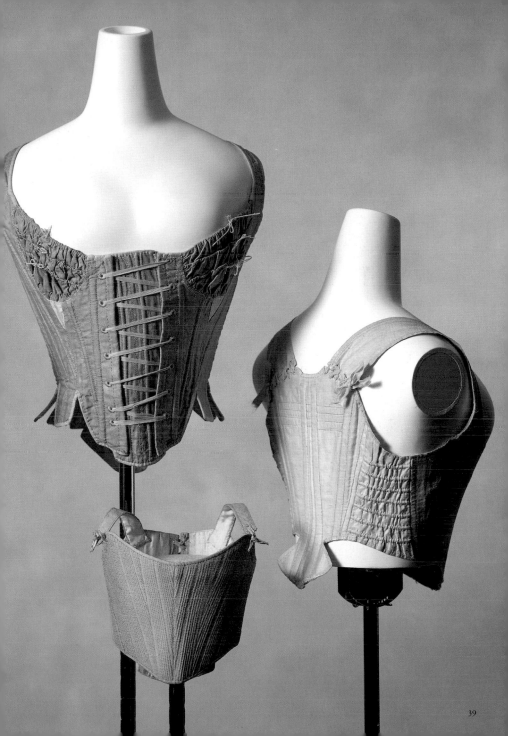

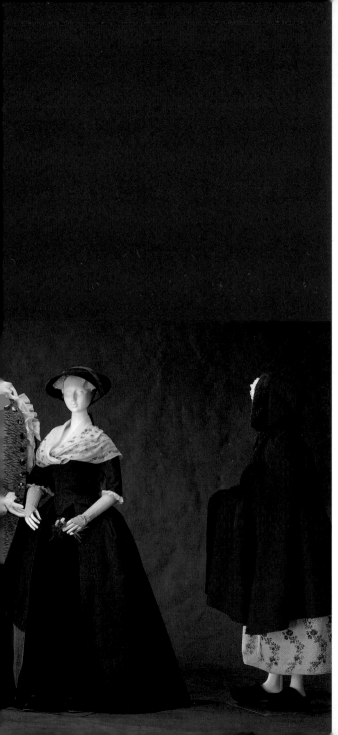

In 1789, the French Revolution broke out. To symbolize separation from the old society, fashion was adopted as ideological propaganda for the new age. The revolutionaries declared their rebellious spirits by their attire, and those who wore extravagant and gorgeous silk clothing were considered enemies of the Revolution. Instead of breeches (*culottes*) and silk stockings, which symbolized nobility, the revolutionaries wore long pants, a jacket (*carmagnole*), a Phrygian cap, a tricolor-cockade, and clogs, all of which were clothing of the lower classes. They were called *sans-culottes*, i. e. those who do not wear breeches (*culottes*).

→ **Man's Shirt and Pantaloons**
Late 18th century
French

Shirt of white plain-weave linen; pantaloons of beige striped cotton satin.
Inv. AC3478 80-23-55, AC6294 89-4-11

→→ **Jacket and Petticoat**
c. 1790s
French

French jacket of red striped plain-weave cotton with center-front lacing; petticoat of white cotton Marseilles-quilt; pattens of leather, wood, and metal.
Inv. AC4686 83-29-2, AC5788 88-19-17

←← **Dress (robe à l'anglaise)**
Late 18th century
English

Brown silk and wool mix; boned at center back; *compères* front; petticoat of black silk taffeta with quilting; cotton fichu with yarn embroidery.
Inv. AC3854 81-16-9

← **Cape and Petticoat**
Late 18th century

Cape with hood of red homespun wool, plush trim (American); petticoat of white quilted cotton woven with garland pattern wool (French).
Inv. AC3664 81-1-11, AC1776 78-41-180

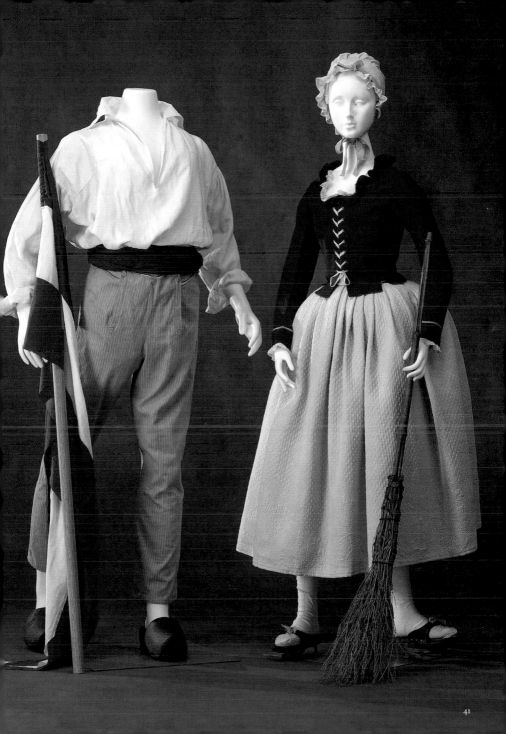

19th Century

During the eighteenth century, France was recognized as a worldwide leader of fashion for women. That reputation was consolidated in the following century, and in the realm of women's fashion France became the unchallenged authority. The English dominated men's fashion, however, thanks to an advanced wool industry, superior textile machinery, and the more refined tailoring techniques developed during the eighteenth century. These distinct influences led to expressions like "Parisian Mode" and "London Tailoring." During the nineteenth century, constantly fluctuating silhouettes characterized women's fashion, whereas men's clothing retained its basic form and changed only in minor details.

The French Revolution of 1789 brought about the collapse of the traditional social hierarchy and saw the rise of a wealthy bourgeoisie that came to characterize French society throughout the nineteenth century. Up until the period of the Second Empire (1852–1870), French nobility enjoyed a renewed position of power, and Empress Eugénie, the wife of Napoleon III, became a prominent fashion leader. The class structure of society again collapsed in the period of the third Republic (after 1870), and fashion leaders once more diversified accordingly. Gradually the central figures of the fashion scene became the wealthy bourgeoisie, actresses, and *demi-mondaines* (high-class courtesans), all of whom became important clientele of *haute couture* in the latter half of the century.

In the second half of the century the pursuit of fashion came to be enjoyed by a larger segment of the population, and trends began to reach even the lower classes. The invention in France of the department store in the 1850s contributed dramatically to this expansion by providing freedom of choice combined with a variety of merchandise at reasonable prices. Due to international exhibitions, the first of which was held in London in 1851, and the arrival of public transport like railroads and steamships, international commerce experienced an unprecedented upswing. Fashion magazines, the titles of which burgeoned rapidly during the nineteenth century, helped Parisian fashion to be recognized around the world by the second half of the century.

The Empire Style and Court Clothing

During the first chaotic revolutionary period a dramatic change occurred in women's fashion. The chemise dress, so named because of its resemblance to a chemise undergarment, became the dominant fashion. Its simplicity stood in stark contrast to the full rococo dresses of the preceding era. Undergarments such as the corset and pannier, which had been necessary to form the exaggerated shape of women's rococo costumes in the previous century, were abandoned. Women preferred to wear thin, almost transparent white cotton dresses with few or no undergarments instead. The chemise, with its high waistline and single-pieced bodice and skirt, had a clean, tubular silhouette. Marie Antoinette wore a prototype of this dress, or *chemise à la reine*, as can be seen in a portrait of her by Elisabeth Vigée-Lebrun (1783). A later portrait, this time of *Madame Récamier* by François Gérard (1802, Musée Carnavalet, Paris; ill. p. 49), illustrates how that dress shape gradually blended into the style of neoclassicism, which celebrated the refined and geometric forms of Greek and Roman antiquity. Diaphanous materials like muslin, gauze, and percale were chosen for their

simplicity. These fabrics also suggested that the function of garments was to drape, rather than mold, the body. The chemise was emblematic of a newly developed aesthetic consciousness and of post-Revolutionary values in France. However, the European winter was too cold for the thin material of the chemise, so cashmere shawls wrapped around the shoulders became popular to warm its wearer and to complement the dress. In addition, practical, tailored English outerwear such as the spencer and the redingote helped to keep the cold at bay. These outer garments showed a strong influence of Napoleonic military uniforms, which had adopted attractive bold designs to emphasize the power of the troops. Cashmere shawls from Kashmir, India, are said to have caught on when Napoleon brought them back to France following his Egyptian campaign in 1799. Because of the exotic patterns and appealing polychromatic colors of the shawls, they became extremely popular as accessories to be worn with the simple chemise dress. They were, however, very expensive at the time, and sufficiently valuable to be recorded in wills and trousseau lists. After the 1830s, the popularity of cashmere shawls spread to the general public and by the 1840s huge shawl industries had sprung up in both France and England to serve the demand. In Lyons, France, luxurious products were made with superior materials, while less expensive woven and printed imitations were mass-produced in the Scottish town of Paisley. The name "Paisley" grew to be so widely known that it became synonymous with the cone pattern often associated with cashmere items. The vogue for cashmere shawls continued until the Second Empire period, when an oversized version worn with crinolines became the dominant style. When the demand for cashmere shawls eventually diminished, the production industries suffered a decline.

After the Revolution, silk was replaced by more favored cotton materials from England, and the silk industry in Lyons, a driving force of the French economy, fell into a serious crisis. Concerned with the economic situation, Napoleon made an effort to revive the French industry by imposing customs duties on imports from England and by prohibiting the public from wearing English muslin, but these measures did not turn the tide of the trend. Upon his coronation as Emperor in 1804, Napoleon began to utilize clothing as a political medium. He issued an imperial ordinance that both women and men wear silk garments at formal ceremonies, and he successfully revived the extravagant court dress style of the pre-Revolutionary era. The silk ceremonial dress and court train (*manteau de cour*) worn by Empress Joséphine at Napoleon's coronation and depicted in Jacques-Louis David's famous painting (1805–1807, Musée du Louvre, Paris; ill. p. 52) show the typical court style of the Empire. The empress's velvet court train with ermine lining symbolizes the luxuriousness and authority of the French court, and illustrates how the ideology of revolution had been firmly set aside. This style of court train long remained a standard garment in the European courts.

During the first decade of the nineteenth century the outline of women's clothing did not undergo any dramatic change, but skirt lengths were shortened after 1810. Once again, undergarments were back in demand; the *brassière*, which later became a prototype of the brassiere, came into use, as did soft corsets without whalebone reinforcements. The preference in clothing material shifted too, from cotton back to silk, as flamboyance in decoration and color returned to fashion.

The Romantic Style

The raised waistlines of the Empire style dress dropped back down to a more natural position by the mid-1820s. Simultaneously, corsets once again became necessary for women's fashion since smaller waists were recognized as an important feature of the new style. Skirts, by contrast, were broadened to a bell-like shape, and their lengths were shortened to reveal the ankles. Elaborately decorated stockings appeared to adorn the

now visible feet. But the most distinctive trend of all during this period was the *gigot* or "leg-of-mutton" sleeve, which ballooned out dramatically from the shoulder and then narrowed in at the cuff. Sleeves of the *gigot* style reached their greatest volume around 1835. Another salient feature of fashion was the décolleté, which became so wide that fichus and capes were often necessary to regulate exposure during the daytime. Berthas and shawl-like garments were also worn frequently. To offset and balance the voluminous sleeves and yawning necklines, hairstyles and hats were also enlarged, with elaborate decorations of feathers, artificial flowers, and jewelry.

The fashion conventions of the period were heavily influenced by Romanticism, which pursued imaginative and romantic impulses and fostered a taste for historical or exotic worlds. The romantic image also demanded that the ideal woman be delicate and melancholic. An active, healthy image was considered vulgar, and hence pale complexions were much admired. The Romantic style also borrowed dress, hair, and jewelry nuances from court dresses of the fifteenth and sixteenth centuries, the favorite period setting for much theatrical drama of the time.

Crinoline Style

The fundamental style of the 1830s continued into the 1840s, but the more extreme embellishments, such as *gigot* sleeves, gradually went out of fashion and calmer designs were restored. Waistlines, nonetheless, grew continuously smaller, and skirts kept expanding. The swelling contour of the skirt was formed through the consecutive layering of petticoats underneath, and their bulk must have proved a severe limitation on women's activities. However, since physical exertion was considered unladylike in high society at the time, heavy clothing was viewed less as a restrictive element than an indicator of affluence. In addition to increased width, skirts were also lengthened again to sweep the floor, thereby emphasizing a woman's modesty. Skirts in the 1850s were characterized by flounces layered horizontally to accentuate the cone shape. The *gigot* sleeves were beginning to disappear. Puffy shoulders gave way to fuller wrist areas. Hats also shrank to small, moderate bonnets or capote shapes, which demurely hid the face. The painter Jean-Auguste-Dominique Ingres accurately depicted these fashion trends and changes in the first half of the nineteenth century.

The end of the 1850s saw a drastic change where skirts were concerned. Thanks to the invention of new clothing materials, the "cage crinoline" or hooped petticoat appeared. In the 1840s, the term "crinoline" referred to petticoats made of *crin* (French for "horsehair") interwoven with hard *lin* ("linen"). After the 1850s, the term came to mean a petticoat with a cage frame constructed out of steel or whalebone hoops, or any wide skirt that included such a cage. With the coming of crinoline, skirts took on extraordinary width. The development of steel wire, major advances in the textile industry, and the practical use of sewing machines all meant that crinolines were enlarged even further. The continuing improvement of looms and dyes made possible a wide variety and quantity of material for skirts. The large demand for fabrics during the time of crinolines continued into the next period as well; the bustle-style skirt was much reduced in girth, but required a great deal of material for its tremendous ornamentation of ribbons and flounces.

The French clothing industry, and in particular the silk textile market of Lyons, received the full benefit of this increased demand for fabric. Napoleon III supported the textile industry as part of his political strategy, and the French bourgeoisie welcomed the policy. Famous couturiers like Charles Frederick Worth designed dresses using technically advanced and artistically refined silk from Lyons. These developments helped Lyons regain its reputation as the distribution center of materials for Parisian fashion.

Bustle Style

From the end of the 1860s, skirts began to grow voluminous at the rear, but markedly flat in the front. This silhouette was made possible by the support of an undergarment called a bustle (*tournure* in French). Bustles were pads that were placed over the buttocks, framed and stuffed with various kinds of material. Skirts or overskirts were sometimes bunched up at the back to lend them an exaggerated shape. With only minor changes in detail, the bustle style continued through the 1880s. The typical silhouette of the 1880s dress can be seen clearly in the painting *A Sunday Afternoon on the Island of La Grande Jatte* by Georges Seurat (1884–1886, The Art Institute of Chicago) depicting a weekend scene among the general public. This painting also reveals the fact that the high fashion style of the bustle had definitely filtered down to the lower classes. In Japan, the bustle style was known as the Westernized attire worn in "*Rokumei-kan*," the official guesthouse, which functioned as the center of Westernization in Tokyo during the Meiji Restoration (1867–1912).

Most dresses after the mid-nineteenth century consisted of two separate pieces, a bodice and a skirt, and as the century drew to a close the desire for decorations and details increased. Dresses came to be adorned at every fold with various and complicated ornaments. As a result, the wearer's natural bodyline was nearly impossible to detect. The only exception to this rule, a one-piece dress that displayed some of the wearer's true shape, emerged in the early 1870s. The dress was dubbed a "Princess Dress," as it was named in honor of Princess Alexandra (1844–1925), who later became Queen of England.

Hairstyles toward the turn of the century reflected a preference for voluminous chignons. Headwear, almost a requirement in the nineteenth century, evolved into small hats with a thin brim, so as to avoid covering the elaborate hairstyles. Toques, with virtually no brim, became especially popular for this reason.

S-shaped Style

The period between the end of the nineteenth century and the outbreak of World War I was referred to as "*la Belle Époque*," when brilliant decadence mingled with a joyful liveliness brought about by people's expectations for the new century. The transitional atmosphere brought a breath of new life to women's fashion. This period saw a dramatic change from nineteenth-century artificial clothing figured by structural undergarments to twentieth-century styles, which pursued the expression of the female body itself. Marcel Proust captured and precisely described in *Remembrance of Things Past* the substantial transition in the structure of women's inner garments.

Important developments emerging from this period were the S-shaped silhouette and the tailored suit for women. The S-shaped silhouette involved a dress that emphasized an extremely small waist by forming large, forward-projecting breasts, and protruding rear. Underwear companies concocted various corsets to achieve the tiny waists sought for this style. The S-shaped figure of women resembled the sinuous, organic forms that were the ideals of Art Nouveau. In particular, the floating line of the bell-shaped skirt with train resembled the floral motif often adopted by Art Nouveau artists. In the field of decorative arts, such as accessories and above all jewelry, the innovation and outstanding quality of Art Nouveau design is clearly evident.

Prior to the nineteenth century, women had already worn tailored suits (*amazone*) with elements borrowed from men's clothing for horseback riding. The fad of suits as clothing for sports and travel began to catch on in the latter half of the century. Finally, between the end of the nineteenth and the beginning of the twentieth century, women started to wear tailored suits for a wide range of general occasions. Women's tailored suits of the time consisted of two pieces, a jacket and a skirt, worn with a shirtwaist (or blouse)

underneath the jacket. Because of this preference for suits, the blouse began to be recognized as an important element of women's fashion, and the trend was accelerated by the appearance of the "Gibson Girls," as portrayed by the American illustrator Charles Dana Gibson (1867–1944).

In the case of dresses, contrary to the tendency to simplify and follow the natural line of the female body, gigantic *gigot* sleeves made a fleeting comeback in the 1890s, but the trend faded away around 1900. Similarly, hats were enlarged and decorated with outrageously extravagant ornaments such as stuffed birds, and these remained popular until the beginning of the twentieth century.

The Development of Undergarments

By the latter half of the nineteenth century, industrial modernization improved the average lifestyle, and clothing was in abundance. A strict social etiquette arose regarding attire, and women had to change their garments seven or eight times a day to meet the dictates of society. The following dress names for example are indicative of the occasions for which women were obliged to change their outfit: morning gown, afternoon tea gown, visiting dress, evening dress (for the theater), ball gown, dinner dress, home gown (before bed), and finally, night gown.

Numerous new kinds of undergarments were created to fill out these new dresses. In addition to the chemise, drawers and petticoats appeared, and all female undergarments took on decorative qualities. Various undergarments supported the rapid changes in silhouette. Crinolines, bustles, and corsets, all essential to the sculpted silhouette of the nineteenth century, were introduced in new models with various novel devises and inventions, many of which were patented.

Dramatic advances in steel manufacturing made possible this new expanded selection of crinolines and bustles. Steel wires and springs began to make an appearance in undergarments, in addition to the usual cloth, horsehair, whalebone, bamboo, and rattan supports. The invention of steel eyelets in 1829 made corsets extremely effective silhouette-makers. They continued to be considered by women the most important undergarment until the beginning of the twentieth century.

The Beginning of the Fashion System

The textile industry accomplished astonishing improvements for certain sections of society in the nineteenth century. The first half of the century witnessed the mechanization of printing and improvements in spinning and weaving machinery. In 1856, the invention of aniline, the first synthetic dye, brought a dramatic change to the color scheme of clothing. The blues, vibrant mauves and deep reds that aniline produced were so fresh that they were quickly embraced by the bourgeoisie. Additionally, sewing machines, made practical by American Isaac Merrit Singer in 1851, showed remarkable performance in garment construction and immediately caught on in the fashion industry. The notion of "ready-made" clothing arose naturally in such an environment. In America, methods of producing ready-made clothing had improved rapidly during the Civil War to meet the increased demand for military uniforms. In France, the first mass-produced clothing, known as "*confection*," was cheap, but came in imprecise sizes.

In contrast to an industry in simple and functional ready-made women's clothing, a high-end *haute couture* market also got off to a good start during this period, and turned out to be equally prosperous. An English couturier, Charles Frederick Worth, established the basis of *haute couture* as it exists in today's

system. He opened his *maison* in 1857 in Paris, and introduced the practice of presenting a new collection of his own designs for each season. Moreover, by putting them on live models, he radically changed the method of the presentation of the clothes. Through Worth, the modern fashion system in which multiple people may purchase one couturier's creative work was successfully established.

Clothing for Sports and Resorts

By the latter half of the nineteenth century, the common standard of living for certain sections of society was so improved that people had more opportunity to enjoy leisure activities. Travel to resorts to escape from hot or cold weather became possible with the advancement of public transportation, and rapidly grew in popularity. A love of sports activities, too, spread to the general public. In this period, the principal elements still present in men's clothing today, such as jackets and three-piece suits, appeared as informal clothing for activities such as travel and sports. Women's clothing for sports such as horseback riding, hunting, and tennis was somewhat practical but not significantly different to their town clothing. Even though sea bathing was considered a medicinally healing practice at the time, women were meant mostly just to frolic at the edge of the sea rather than go swimming in the water. Their bathing dresses were meant to double for sports and for beach excursions. More practical swimming outfits, swimsuits consisting of tops and trousers, finally came about in the 1870s.

As the nineteenth century drew to a close, skirt lengths began to climb due to the popularity of more active sports like golf and skiing. Knitted sports sweaters were introduced and a men's jacket called a "Norfolk jacket" was adapted into hunting wear for women. Scottish tartans, practical to use and unique in colors and patterns, became fashionable as resort clothes after they were worn by Queen Victoria. Furthermore, trouser-shaped "bloomers" finally became accepted as functional cycling clothes for women in the 1880s. First advocated in the mid-nineteenth century by the feminist Amelia Jenks Bloomer, from whom they took their name, the arrival of bloomers coincided with newly begun campaigns for women's rights.

Japonism and Parisian Mode

With the opening of Japan to international trade in 1854, European interest in Japan grew rapidly, and "Japonism" emerged as a trend in the early 1880s, lasting until around 1920. Japonism influences in fashion appeared in various ways. First, the Japanese kimono itself was worn as an exotic at-home gown, and kimono fabrics were utilized in the making of Western dresses. Fine examples of bustle-style dresses made of *kosode* (visiting kimono) material survive. Japanese motifs were also adapted and applied to European textiles. In textiles produced at the time in Lyons, for example, Japanese patterns such as natural motifs, small animals, and even family crests can be found. At the beginning of the twentieth century, the custom of wearing a kimono as an at-home gown can be seen in *Madame Hériot* by Pierre-Auguste Renoir (1882, Hamburger Kunsthalle, Hamburg). Eventually the garment evolved into a more thoroughly Westernized, kimono-shaped at-home gown. The word "kimono" came to be used in a broader sense in the West, encompassing a variety of lounging robes. Ultimately, in the twentieth century, the silhouette and flat construction of the kimono would exert a great influence on three-dimensional Western clothing and the world of fashion.

Miki Iwagami, Lecturer at Sugino Fashion College

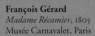

François Gérard
Madame Récamier, 1805
Musée Carnavalet, Paris

Dress
c. 1810

Dress of white cotton muslin; border
embroidered with red wool; shawl of
purple Spitalfields silk gauze
Inv. AC292 77-12-9

From left to right, 1–6

1. Dress
c. 1800

White cotton gauze dress embroidered
with bouquet pattern at front bodice
and hem.
Inv. AC5464 86-42-2

2. Dress
c. 1805

White cotton muslin dress with train;
whitework with small floral motif;
white linen muslin fichu with poly-
chrome embroidery, long hanging
edges from shoulder.
Inv. AC293 77-12-10

3. Dress
c. 1810

Beaded white cotton muslin dress;
shawl of beige linen gauze with Turk-
ish gold and silver embroidery, steel
ornaments at four corners.
Inv. AC4319 82-17-38

4. Dress
c. 1800

Striped muslin dress with train;
whitework with floral pattern; red silk
crepe shawl woven with floral pattern;
white silk satin bag with chenille
embroidery and tassel.
Inv. AC4417 83-1-9

5. Dress
c. 1805

White cotton muslin dress with red,
blue and silver embroidery; with train
and petticoat.
Inv. AC5466 86-42-4AB

6. Dress
c. 1810

White cotton muslin dress; border
embroidered with red wool; shawl of
purple Spitalfields floral silk gauze.
Inv. AC292 77-12-9

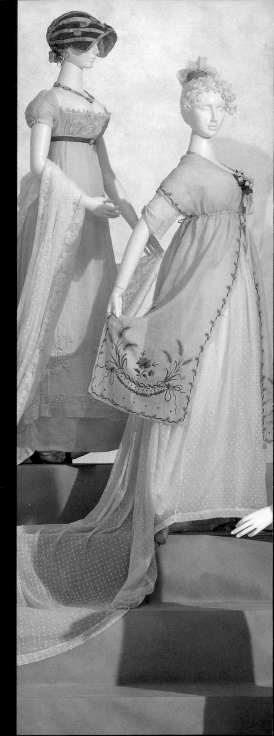

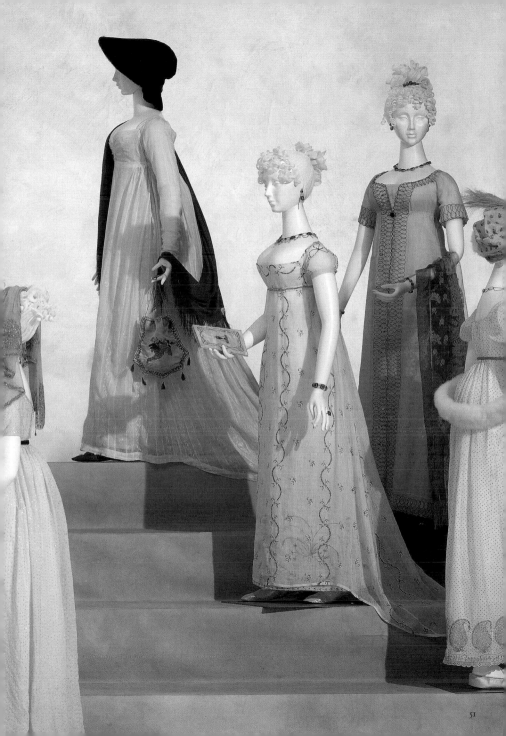

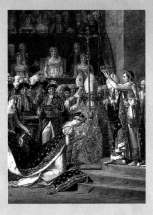

Jacques-Louis David
*Consecration of the Emperor Napoleon
I and the Coronation of the Empress
Joséphine in the Cathedral of Notre-
Dame de Paris, December 2, 1804*
(detail), 1805–1807
Musée du Louvre, Paris

The late eighteenth century was a
period of transition from the extrava-
gant silk dress to the simple chemise
dress of white cotton. A wave of
Anglomania meant that the simple
English cotton fabrics became very
popular, and the Lyons silk industry,
important for the French economy,
suffered a severe blow. To boost the
industry Napoleon issued an Imperial
decree that men and women should
wear silk clothes at public ceremonies,
and people were encouraged to wear
silk costumes at the French court.
These two dresses epitomize the glori-
ous, elegant beauty of the fine silk
material.

Formal Dress
c. 1805

White figured silk; stripes of ground
and floral pattern of silver metallic
thread; dress with train; shawl of cot-
ton lace with small floral pattern.
Inv. AC5655 87-31-1, AC5904 88-55-23

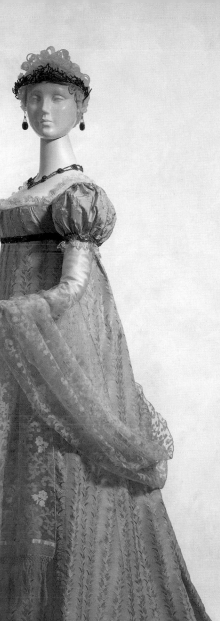

← **Formal Dress**
c. 1805

Figured silk with leaf-shaped motif;
dress with train; shawl of white silk
gauze with woven wool floral pattern,
yarn fringe.
Inv. AC5066 85-3-2

Pages 54/55
In French, women's riding costumes
were called *amazones*, named after the
female warriors in Greek mythology.
These clothes emulated men's fashion,
but women were not allowed to ride a
horse astride, and always had to wear
a skirt and ride side-saddle. On page
55 is a typical woman's riding costume
from the early nineteenth century. The
tight tailored jacket was designed in a
style similar to that of a man's jacket.
The skirt is long to protect the legs
from showing while riding side-sad-
dle.

Page 54 left
**Man's Jacket (frock coat) and
Breeches**
c. 1815

Jacket of navy wool broadcloth, with
tails and vertical-cut front hem; beige
buckskin breeches.
Inv. AC5897 88-55-16

Page 54 right
**Hunting Jacket (spencer) and Petti-
coat**
c. 1815

Jacket of navy broadcloth; petticoat of
white cotton lawn with matching tape
and inset of cotton muslin.
Inv. AC3187 80-8-1, AC5895 88-55-14

Page 55
Riding Suit
c. 1810

Black wool broadcloth; set of tailored
jacket and skirt of appropriate length
for horse riding.
Inv. AC5313, 86-8-2AB

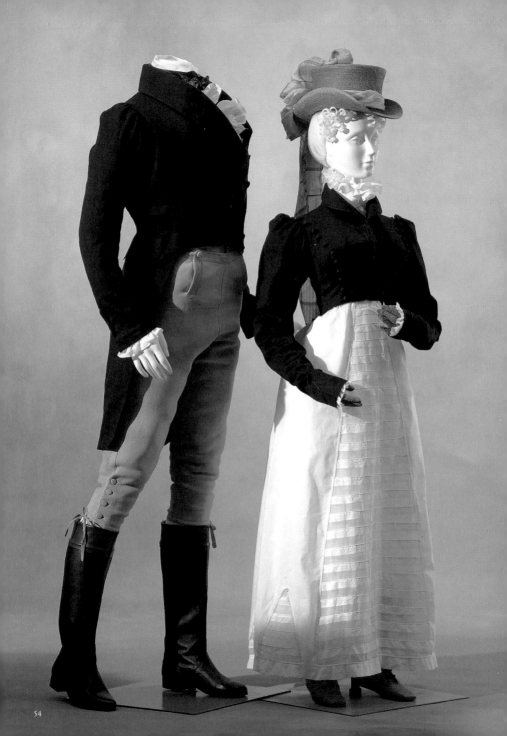

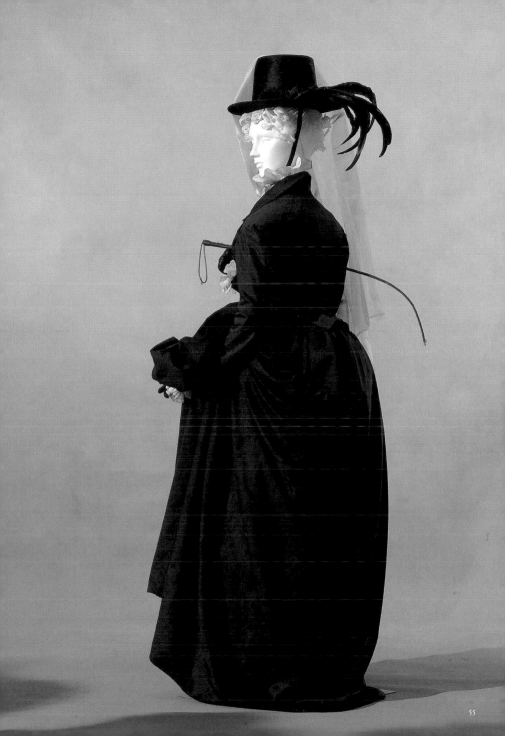

The thin muslin chemise dress was little protection against the rigors of a freezing European winter, so the cashmere shawl and the spencer quickly became fashionable. As well as providing warmth and protection from the cold, they were also valued for their decorative characteristics. The English-style spencer was fashionable from the 1790s to the 1820s. It was a short, tailored jacket with long, tight-fitting sleeves that covered the hands. It took its name from England's Earl Spencer (1758–1834), who wore this kind of jacket. Initially a man's garment, its practical features meant that it soon came to be worn by women as well.

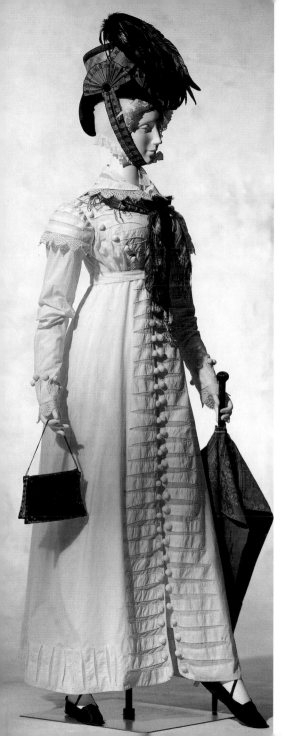

Left
Jacket (spencer) and Petticoat
c. 1815

Jacket of red cut velvet with piping and
wrapped buttons in hussar style; white
petticoat of plain-weave cotton; shirring at
hem.
Inv. AC3145 80-5-36A, AC5893 88-55-12

Center
Dress
c. 1815

Two-piece dress of white cotton lawn;
jacket with hussar-style braid and pom-
poms; petticoat with cord embroidery and
triple frills; embroidery, frills and small
ball decorations all over.
Inv. AC5884 88-55-3, AC5885 88-55-4

Right
Redingote (à la Hussarde)
c. 1815

White plain-weave cotton; hussar-style
Brandenburg piping and pompoms; metal
net bag with silver closure.
Inv. AC5174 85-37-2AB

Journal des Dames et des Modes, 1814

All of the handbags shown here are known as "reticules," which are usually small bags with a strap. From the late eighteenth century to the early nineteenth century, skirt outlines changed from a wide, expansive shape to the slender Empire style that recalled the form of a Greek column. As a result, the pocket that had previously been worn inside the dress could no longer exist, and a handbag carried on the outside was needed in its place. The pineapple (right) is a specialty of the Island of Martinique, the birthplace of Empress Joséphine; such exotic motifs were very fashionable at the time.

Reticule
1810–1815

White silk satin embroidered with polychrome floral basket motif; fly fringe trimming.
Inv. AC7576 92-17-10

Reticule
c. 1800

Yellow and green silk knit; pineapple
shape with trimming of silver beads
and tassels.
Inv. AC4411 83-1-3

Reticule
Early 19th century

Gold and green silk knit with check
pattern; medallion with architectural
scene; tassel.
Inv. AC7574 92-17-8

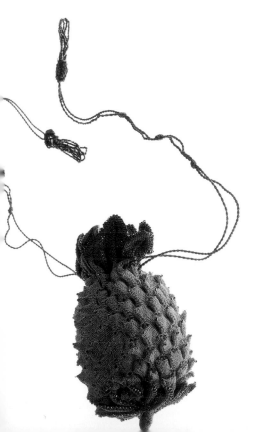

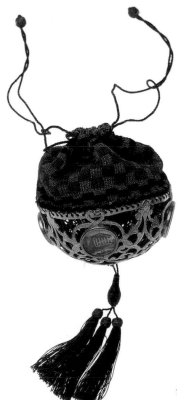

59

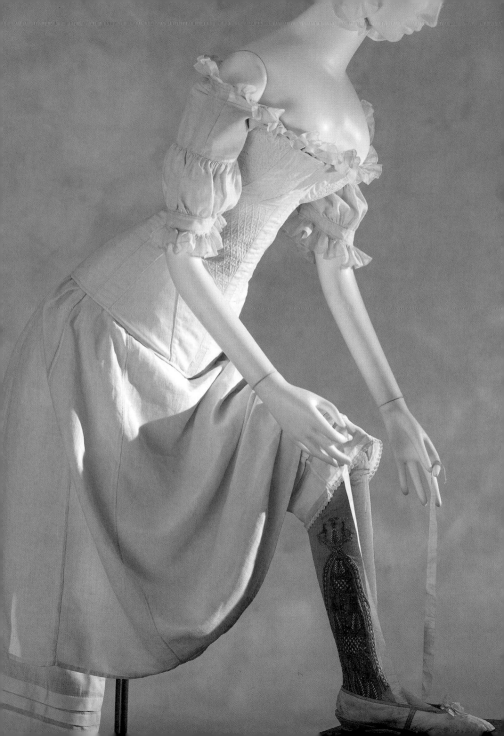

The high waistline was in fashion from the end of the eighteenth century, but the waist returned to its natural position around the mid-1820s. Consequently, a thin waist became important, and the corset was once again in demand. From then on the thin-waistline obsession escalated, and the corset, although changing in material and shape, continued to tighten the waist until the beginning of the twentieth century.

The corsets shown here are of the type worn when thin waists came back in the 1820s. This type has a soft feel to it, and the pressure that it puts on the waist when tightened is not excessive. Shown on the bottom right are sleeve pads to be worn under the fashionable *gigot* sleeve so that that the puff of the sleeve would stand out.

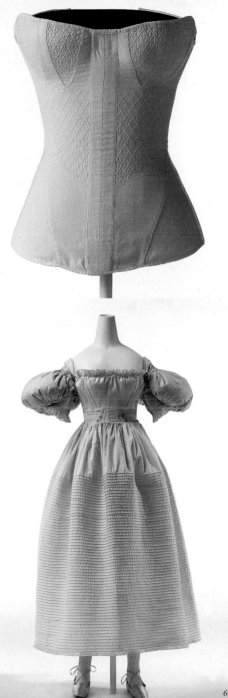

Left and above right
Corset, Chemise and Drawers
1820s

White corset of quilted cotton satin with soft busk and bone (bust: app. 80 cm; waist: app. 49 cm); chemise and drawers of white linen.
Inv. AC5140 85-24, AC2827 79-24-21, AC5661 87-33-1

→ **Corset, Chemise, Petticoat and Sleeve-pads**
1830s

White corset of cord-quilted cotton satin with embroidery; white cotton chemise; linen petticoat; sleeve-pads of cotton chintz stuffed with down.
Inv.AC219 77-11-59, AC564 78-2-18, AC1149 78-35-4, AC9455 97-18-2AB

The word "dandy" first surfaced as a
name for refined men in England in
the early nineteenth century. Encour-
aged by the Restoration in 1815, aristo-
crats who had fled to Britain returned
to France, and the dandies who
returned to Paris became a feature of
the city. Their clothes were in the sim-
ple and functional style of English
fashion. Since the style was simple
without decoration, a cut-to-fit, per-
fect tailoring technique and the use of
superior-quality fabric were stressed.
The carefully combined color scheme,
and the cut that perfectly fits the body
line, make this typical 1830s-style
dandy suit almost a work of art.

Man's Ensemble
1830s

Dark brown tail coat of wool broad-
cloth with velvet collar; waistcoat of
black silk satin with cut-velvet woven
floral pattern; trousers of plaid cotton
twill; silk pongee scarf.
Inv. AC7765 93-19-6AD

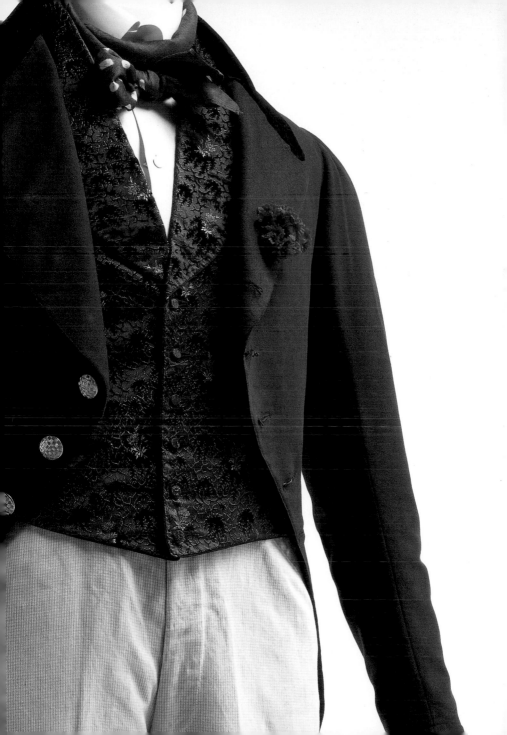

Ingres was acclaimed for painting portraits that precisely captured the personality and social background of the model. His clients were from the newly powerful bourgeoisie, and the extravagant clothes that signified the social position of this class were depicted by Ingres' exceptional skill.

→ **Jean-Auguste-Dominique Ingres**
Madame Moitessier (detail), 1856
National Gallery, London

Evening Dress
c. 1855

Creme silk and wool mixed gauze with floral print; triple layered tiered skirt.
Inv. AC9475 97-23-6AB

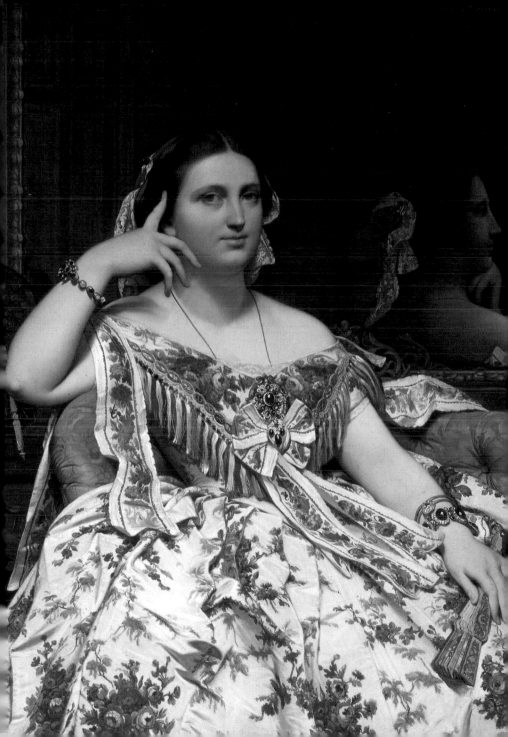

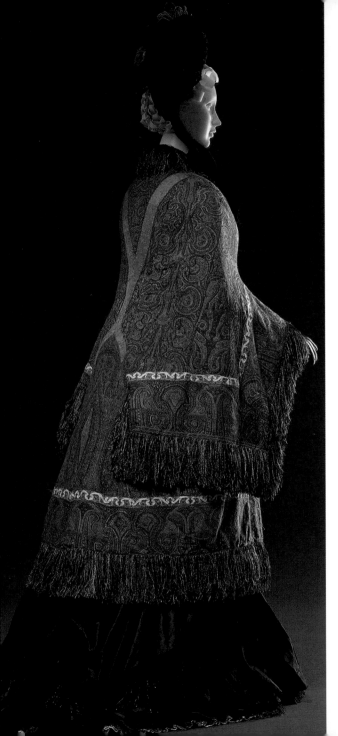

The cashmere shawl was first imported into Western Europe at the end of the eighteenth century, and became a popular item at the beginning of the nineteenth century for its rarity and exoticism, as well as for its practicality. Cashmere shawl comes from the Kashmir region in the northwest of India, where the short soft hairs of the mountain goat were hand-spun into cashmere yarn and woven into woolen cloth. This was a light, soft cloth, with a shine like silk, the highest quality of all the early woolen fabrics. It was the fabric most desired by women throughout the nineteenth century, a desire often satirized in the novels of Balzac. Cashmere shawl became a major industry in France and England, but there are records showing that up until the 1840s the best quality was made in Lyons, and cheaper imitations were made at Paisley, in Scotland.

During the Second Empire (1852–1870), crinoline dresses became so large that it was impossible to wear a coat over them, and even larger cashmere shawls came into fashion. With the change to the bustle style the shawl also changed, and the *visite* made its appearance. As shown by the display on the left, the cashmere shawl changed to a *visite* or indoor garment, and gradually became a piece of indoor decoration, disappearing from the fashion scene.

← **Visite**
Late 1870s

Polychrome fabrics woven in Kashmir (India); fringe trimming on collar, sleeve and hem.
Inv. AC4843 84-18-3

→ **Cashmere Shawl**
1850s–1860s

Polychrome cashmere shawl, rectangular with fringe at edges, made by Frédéric Hébert, shawl maker in Paris.
165 x 386.5 cm
Inv. AC10295 2000-9-2

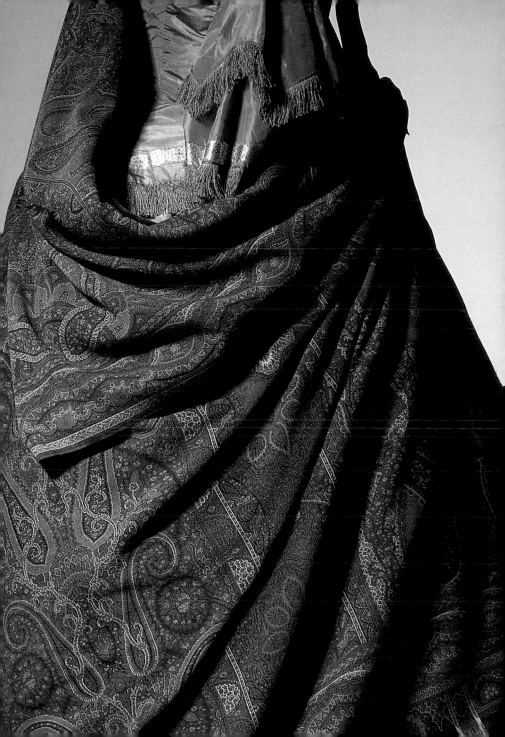

↓ **Woman's Shoes**
Peter Robinson
Label: Peter Robinson Ltd costume
REGENT ST. W.
Late 1860s

Red wool base with polychrome floral
embroidery (called Bokhara embroi-
dery, a traditional craft in Bokhara,
Uzbekistan); silk taffeta rosette and
metal buckle.
Inv. AC4852 84-18-11AB

→ **Dressing Gown**
Jane Mason
Label: JANE MASON & Co. (Late
LUDLAM) 159 & 160 OXFORD
STREET
c. 1866
English

Twill wool printed with polychrome
cashmere pattern; no waist seam at
front; volume at side back; front open-
ing with wrapped button and match-
ing belt.
Inv. AC4429 83-2-3

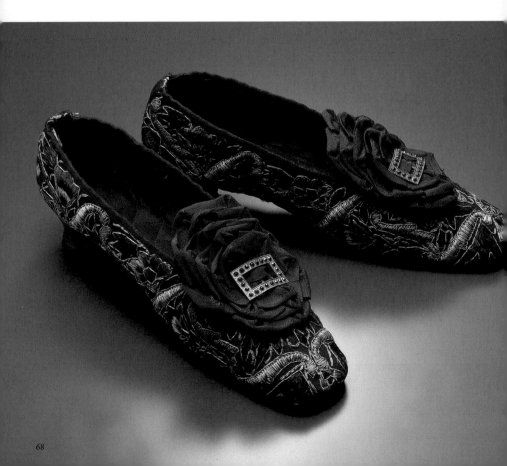

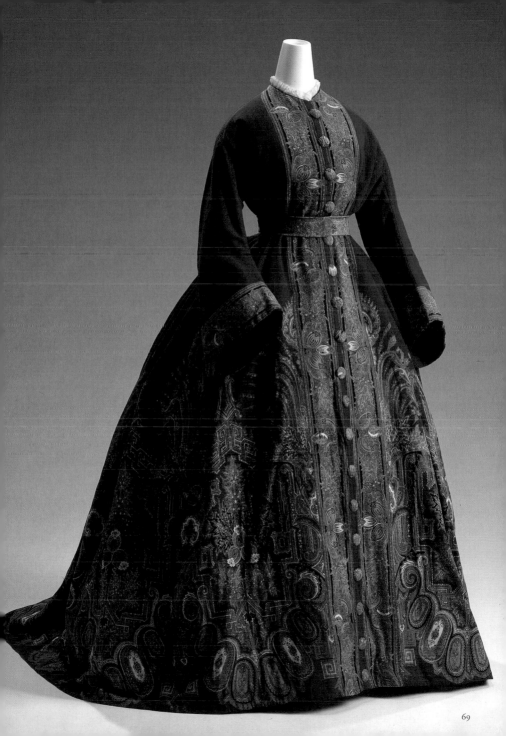

The princess dress was named in honor of Alexandra, Princess of Wales (later Queen of Britain). It had no horizontal waist seam, but used vertical tucks to fit closely to the waist, emphasizing the bust and hips. It was fashionable around 1880, and though it was only in style for a short time, it can be seen as an example of a nineteenth-century "body-conscious" style. This example is made of organdy, inlaid with three different varieties of plant-patterned Valenciennes lace. Approximately 50 meters of laces was used for this dress.

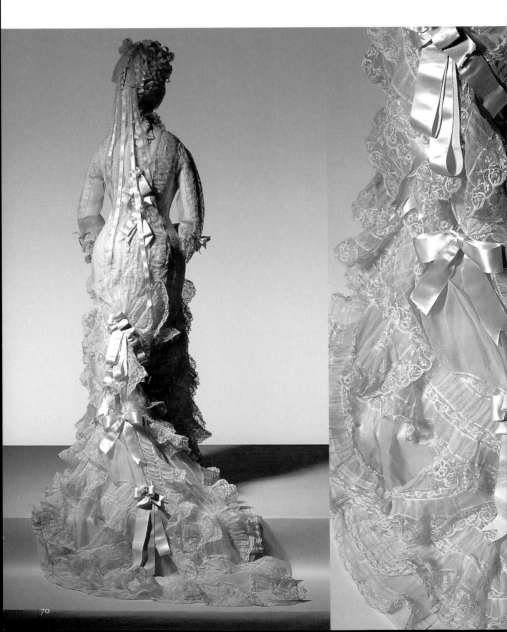

Anonymous
Reception Dress
Label: (illegible)
c. 1880

White linen organdy and Valenciennes lace;
one-piece princess dress; train with dust ruffle.
Inv. AC679 78-20-4AB

James Tissot
The Reception (detail), 1878
Musée d'Orsay, Paris

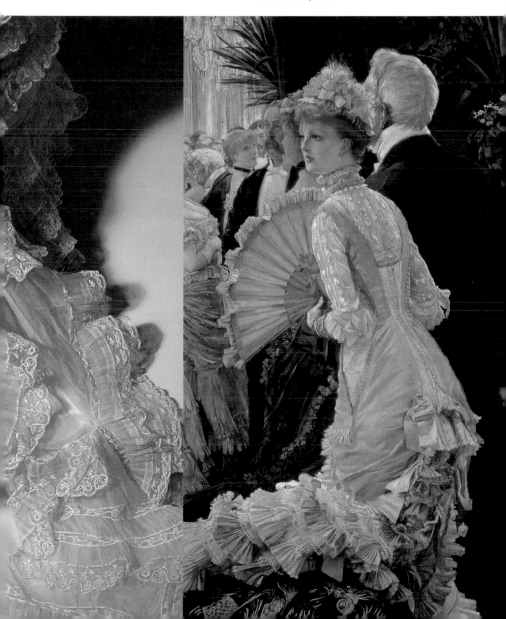

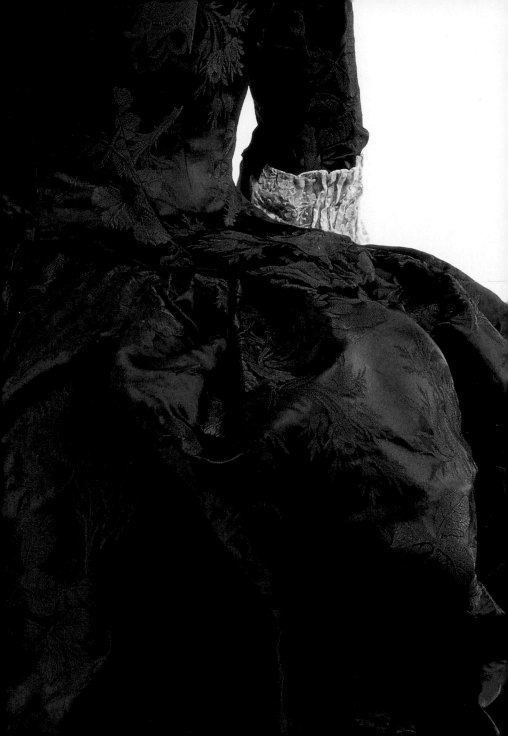

The thickness and stiffness of high-quality silk fabric was ideal for creating the clear, sharp lines of the bustle style. Of all the quality silks of the time, Lyons silk was the very best. The fashionable silhouettes at that time used large quantities of Lyons silk fabric.

This example, a combination of the complimentary colors blue-green and red, shows the new taste in colors, which was made possible with the new chemical dyes that appeared in this period.

N. Rodrigues
Reception Dress
Label: N. RODRIGUES Paris
1875–1879

Blue-green silk satin brocade with woven pattern of red roses; two-piece dress; lace at neckline, front opening and cuffs; silk satin bows at cuffs; train with silk thread fringe and wooden beads.
Inv. AC9232 95-19-6AC

Throughout the nineteenth century, narrow waists were greatly admired. Women used corsets in an effort to get closer to a perfect physical form. This forcible distortion and squeezing of the body continued up until the beginning of the twentieth century. With the development of modern technology, inventors created corsets of considerable ingenuity. In particular, the introduction of steel allowed great improvements in the tightening of the waist with a corset.

Corset
1880s

Blue silk satin; steel busk; bone.
Bust: 76 cm. Waist: 49 cm.
Inv. AC212 77-11-52AB

→ **Edouard Manet**
Nana (detail), 1877
Hamburger Kunsthalle, Hamburg

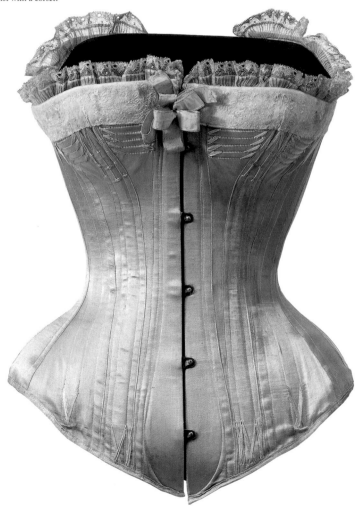

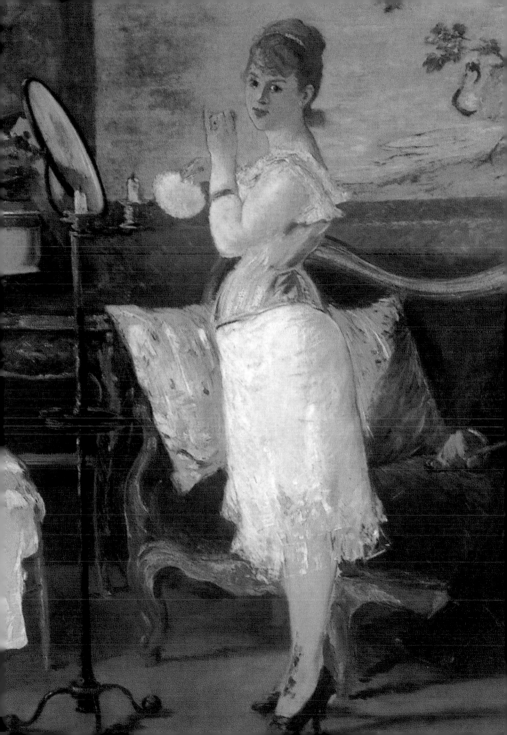

1. Corset
c. 1868–1873

White cotton; steel busk; bone.
Bust: 84 cm. Waist: 54 cm.
Inv. AC4036 81-25-150AB

2. Corset
Label: I. C. A LA PERSEPHONE
1890s

Black silk satin embroidered with
small floral pattern; steel busk; bone.
Bust: 85 cm. Waist: 56 cm.
Inv. AC3674 81-1-21AB

3. Corset
1870s–1880s

White cotton net; steel busk; bone.
Bust: 66 cm. Waist: 45 cm.
Inv. AC2876 79-26-19AB

4. Corset
1860s–1870s

Brown raffia and cotton; steel busk.
Bust: 84 cm. Waist: 67 cm.
Inv. AC9246 95-29-AB

5. Corset
1865–1875

White cotton coutil; steel busk; bone.
Bust: 84 cm. Waist: 52 cm.
Inv. AC3159 80-5-49

6. Corset
1880s

Blue-gray cotton satin; steel busk; bone.
Bust: 104 cm. Waist: 81 cm.
Inv. AC2843 79-25-6AB

7. Corset
Label: LOOMER'S
1885–1895

Brown cotton satin; steel busk; bone.
Bust: 81 cm. Waist: 51 cm.
Inv. AC5144 85-27AB

8. a/b Corset (front and back)
Label: THOMSON'S
1885–1889

Wine-colored silk satin; steel busk;
bone.
Bust: 89 cm. Waist: 59 cm.
Inv. AC1495 78-39-29AB

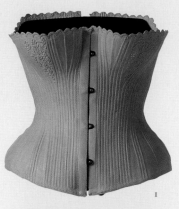

1

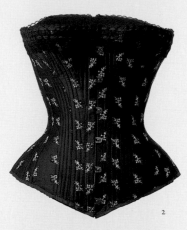

2

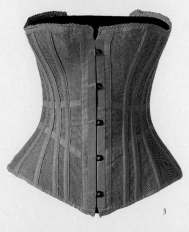

3

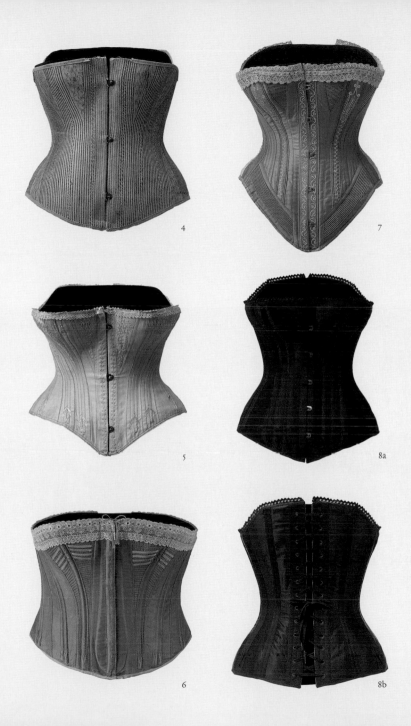

4

7

5

8a

6

8b

In the late 1820s skirts began to expand once again. Women wore several layers of petticoats beneath their skirts to increase their volume. The simple idea of weaving horsehair (*crin* in French) into the petticoat cloth appeared in the early 1840s, and the crinoline was born. Skirts could then be held out with a single layer of cloth. In the late 1850s people began using connected horizontal hoops of wire or whalebone to produce new and original versions of the crinoline. But with the appearance of this light, easy-to-wear crinoline the transition to larger skirts accelerated, and they reached their maximum size in the 1860s. This structure carried over to the next trend, the bustle style, in which the skirt was expanded towards the rear.

Left
Crinoline
c. 1865

White and purple cotton with twelve steel-wire hoops.
Diameter from left to right: 73 cm; from front to back: 81 cm; circumference of hem: 244 cm.
Inv. AC2899 79-28-3

Center
Crinoline
Label: THOMSON'S
c. 1875

Red cotton with twelve steel-wire hoops.
Diameter from left to right: 58 cm; from
front to back: 59 cm; circumference of hem: 189 cm.
Inv. AC1064 78-30-75

Right
Crinoline
1865–1869

White cotton with nineteen steel-wire hoops.
Diameter from left to right: 105 cm; from front to back: 98 cm; circumference of hem: 318 cm.
Inv. AC2227 79-9-32

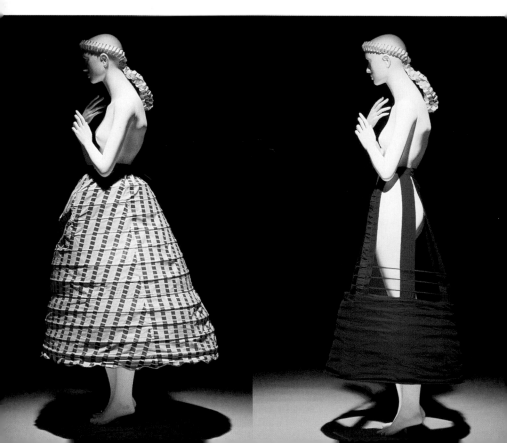

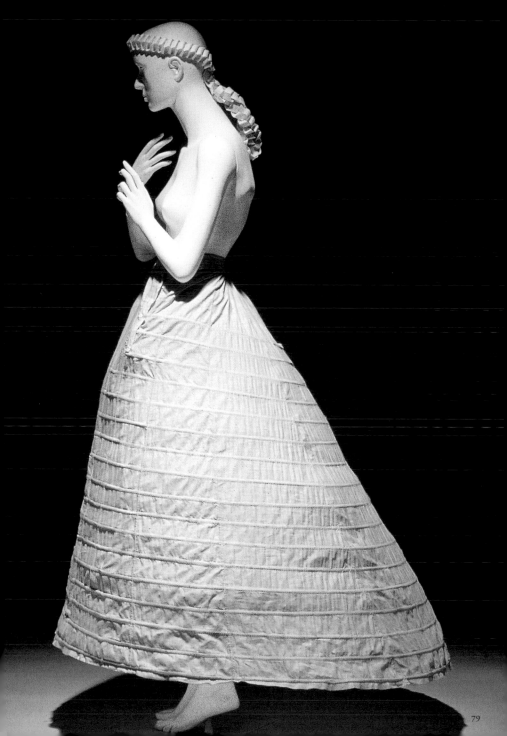

The use of crinolines allowed the over-all expansion of the skirt, but in the mid-nineteenth century this expansion quickly became restricted to the back of the dress. The large lower hem of the crinoline skirt was scaled down, the skirt became flat over most of its surfaces, and only the rear projection remained in the new silhouette. This shape was supported from the inside by the bustle. In the period from the 1870s to the 1880s, there were many variations on the now fully developed bustle, supporting the form from the inside, and fashionably emphasizing the posterior. A variety of bustle con-structions appeared, including cush-ions filled with horsehair, stiffly starched cloth, and frames of whale-bone, bamboo and rattan.

Bustle
1870s

Red and brown striped cotton
with steel wire.
Inv. AC1929 79-1-81

Bustle, Corset, Chemise and Drawers
1870–1880s

Bustle of brown and beige striped
cotton with thirteen steel wires placed
at back; corset of black silk satin with
yellow silk ribbon and embroidery;
chemise and drawers of white cotton.
Inv. AC237 77-11-75,
AC3103 80-4-3AB, AC714 78-20-37,
AC1372 78-37-86

Along with Japonism in fashion, hand-crafted objects made for solely for the European market were imported into Western Europe. This fan, used in France, has *ukiyo-e*-style representations of people on one side; the other side features baskets of flowers including autumn leaves, chrysanthemums and insects. Such fans, ornamented with *netsuke*-style tassels, were often collector's items in nineteenth-century Western Europe.

In 1867 the Satsuma domain, along with the Shogunate and the Saga domain, took part in the Paris International Exhibition. The Satsuma

domain displayed an interest in foreign countries at an early stage, and around 1860 began to make Satsuma-style ceramic buttons for export. With their Japanese style and patterns, these ceramics became very popular in Europe and America, and were dubbed "*Satsuma*" buttons.

Buttons
Label: Satsuma
c. 1900, Japanese

Satsuma; set of six; *samehada* ("sharkskin") ground with *kinrante* (heavy gilding); celestial maiden motif.
Inv. AC9127 94-16AF

Fan
Late 19th century, Japanese

Ivory; lacquer work with people, insects and flower basket motif; tassel in *netsuke* style.
19.6 cm
Inv. AC2802 79-23-15

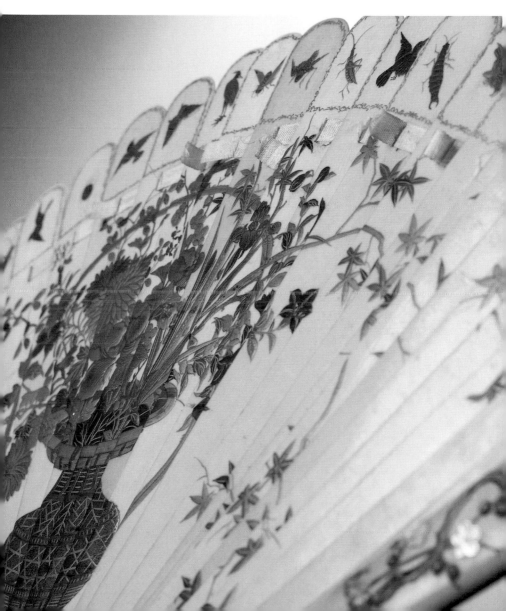

At the end of the nineteenth century, major kimono shops like Iida Takashimaya and Mitsukoshi showed interest in Western European markets and greatly expanded their foreign trade business. These silk coats with Japanese embroidery are one of the many products exported to Europe during that period.

On the left is an example of a "theatre coat," fashionable in England around 1904. Inspired by the Chinese-style Mandarin robe, worn by Qing dynasty public officials, this example was made for export in Japan. On the right is an example of a kimono-style indoor gown. The body flares gently down to the hem, and the collar is also curved. While retaining the essential shape of the kimono, it has been deliberately adapted for the European market.

Iida Takashimaya
Evening Coat (Theater Coat)
Label: S. IIDA, "TAKASHIMAYA,"
KYOTO & TOKYO. JAPAN
c. 1900–1903

White silk padded satin; embroidery of white chrysanthemum pattern and wavy pattern at front opening, sleeves and shoulders; round collar; kimono sleeves; side slits; Chinese knots at front opening; Mandarin-robe style.
Inv. AC9071 94-00

Iida Takashimaya
Gown
Label: S. IIDA, "TAKASHIMAYA"
SILKS & EMBROIDERIES. KYOTO.
c. 1904–1908

Gray plain-weave silk; embroidery of
peacock on cherry blossom tree from
front to back bodice; *kumihimo*
(Japanese cord) and tassels at cuffs;
fuki (padded hem) in pink; *habutae*
lining.
Inv. AC9265 95-41-1

These slippers with depictions of
Japanese scenery must be souvenirs
from Japan, or products for export to
Western Europe because "made in
Japan" is imprinted on the sole. Slip-
pers, like dressing gowns and fans,
were among the first products export-
ed to Western Europe during the
nineteenth century. The design where
the left and right combined together
completes one picture is a strong char-
acteristic of a Japanese product. On
the buckle of the bag is a *netsuke*-style,
Japanese three-monkey ornament.
Netsuke, with its intricate design tech-
nique, was one of the most popular
Japanese decorative arts in Western
Europe, and in the nineteenth century
they quickly became collectors' items.

Anonymous
Slippers and Bag
1920s
Japanese

White leather; imprinted, hand-paint-
ed; slippers with fur, 4.5 cm heel,
"made in Japan" and "7" (size)
imprinted on sole; bag with *netsuke*
buckle, strap on back, zipper and mir-
ror inside.
13.3 x 20 cm
Inv. AC7624 92-35-3AB, AC7625
92-35-4

In the nineteenth century women's social status saw improvement, their legal rights began to increase, and the scope of their activities expanded. Leisure time increased, railways and other means of transportation improved greatly, and sports and travel became popular. There was still no such thing as "sportswear," but, for particular occasions, women developed a more rational and practical approach to clothing.

On the left are casual outdoor clothes with particularly little decoration. These were the new styles in women's clothes; they were light and easy to wear, as a result of these transformations inside society. On the right is a simple, practical suit for playing tennis.

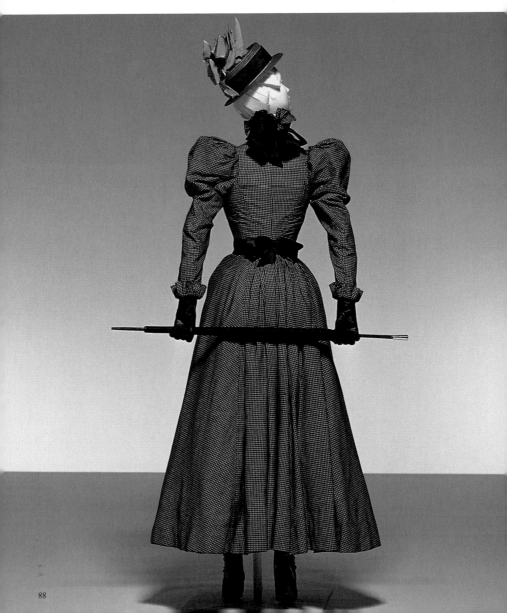

↙ Anonymous
Day Dress
c. 1892

White and black plaid wool twill; set
of bodice and skirt; puffed sleeves;
frills at collar and cuffs.
Inv. AC883 78-24-58AB

↓ Anonymous
Tennis Suit
c. 1890

White cotton piqué; tight tailored
jacket and ankle-length skirt.
Inv. AC2127 79-6-13AB,D

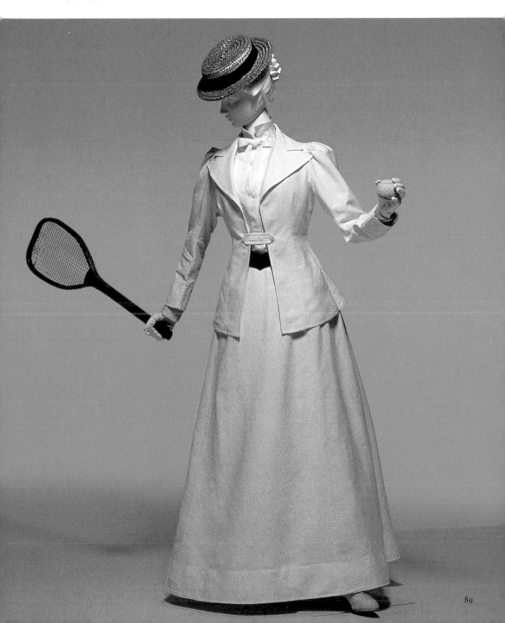

20th Century · First Half

World War I quickly and completely demolished the old social systems and values that had begun to crumble at the end of the nineteenth century. Society changed, and consequently the whole look of society changed too. The rise of a powerful middle class brought about a new lifestyle, and as women stepped out of the home to participate more fully in the world at large, they discarded the corset and sought more functional clothing. Fashion designers as well as artists thought hard about new types of apparel. While it is important to understand the impact that the two World Wars had on fashion, it is also true without a doubt that *haute couture* functioned as the central influence leading fashion in the first half of the twentieth century. Also during this period, various vital media systems were established which spread the fashions of Parisian *haute couture* around the world.

The Quest for a New Type of Clothing and The Escape from the Corset

World War I accelerated shifts in various aspects of society and culture. An increasing number of highly educated and professional women, the more frequent use of automobiles, and a growing fascination with sports were just some of the developments that resulted in a whole new lifestyle. Clothing, too, evolved to acquire the shape of the new epoch. For active women in this period, day-to-day clothing gradually achieved a certain degree of functionality in the form of tailored suits.

On the other hand, prominent dress designers such as Charles Frederick Worth, Jacques Doucet and Jeanne Paquin, who had all started *haute couture* houses during the previous century, still adhered to an *Art Nouveau* sensibility, aiming for ultimate beauty through a combination of elegance and opulence. Their ornate creations required long corsets to achieve the desired effect, an artificial S-curve silhouette. Long corsets distorted the natural body and hindered mobility so much that, although women followed such styles in public, they understandably sought release from such restrictive attire inside their own homes. The popular at-home garments were tea gowns with loose silhouettes, since they allowed women to loosen their corsets underneath.

It was Paul Poiret who first put forward a new line of fashion that did not require the use of a corset. His "Confucius Coat," with its straight cut and ample shape, first appeared in 1903. Next, in 1906, he created the "Hellenic Style," a corset-free and high-waisted design. With few exceptions, since the time of the Renaissance western women's clothing had required a waist-cinching corset as the main shaping element. Poiret rejected the use of a corset in female garments, shifting the supporting point of gravity from the waist to the shoulders.

According to his autobiography, Poiret's designs arose not from a desire to release women from the centuries-old tyranny of the corset, but from an ardent quest for a new form of beauty. His garments, nevertheless, achieved something that even the disapproval of feminist activists and medical doctors during the late nineteenth century had failed to do: they liberated women from the corset. Consequently, fashion in the twentieth century evolved from a corseted, artificial form to a more natural shape supported by a brassiere.

Poiret's work was decorated in a splendidly exotic style, and employed strong, bold colors. He created harem pants, as well as the aptly named narrow-hemmed hobble skirt, and turbans inspired by the Orient. His designs fed into a nostalgia for foreign lands that characterized this period of the twentieth century. Orientalist painting, popularized in the late nineteenth century, and the publication of *A Thousand and One Nights* in translation in the early twentieth century fostered a yearning for the Orient. The sensational début of the *Ballets Russes* in Paris in 1909 was applauded for its exotic magnificence and certainly added to the trend. Attention turned increasingly to Japan, which opened its doors to the West in the late nineteenth century. By the time of the Russo-Japanese War (1904–1905), Japan's cultural influence had been dubbed "Japonism." Both Orientalism and Japonism made an impact on various fields of art and literature. Poiret and another fashion house, Callot Sœurs, found inspiration in exoticism and the sensuous beauty of the East. They were drawn to the patterns and colors of fabrics as well as the structure of garments such as loosely fitted harem pants and the exotic Japanese kimono. The flat shape and openness of the kimono, in fact, suggested one direction that the new relationship between the body and clothing would go.

The search for a new style in clothing was observed in other European countries aside from France. Spanish-born Mariano Fortuny, inspired by Greek shapes and forms, created a classically pleated dress and named it "Delphos." The "Delphos" was an innovative design combining functionality with decoration. Fine pleats gently encased the body, and ornamentation was supplied almost entirely by movement, as the slightest stir changed the glow and hue of the textile. The Wiener Werkstätte founded in 1903 by Josef Hoffmann and others also created new clothing. The Wiener Werkstätte started business mainly to engage in the production of architecture, craft works, and bookbinding, but it opened a fashion department in 1911 with its own clothing line, including such items as loose-fitting sack dresses.

Around the turn of the century, the media necessary to transmit fashion news were developed and their realm of influence spread rapidly. Fashion magazines such as *Vogue* (1892-, New York) and *Gazette du Bon Ton* (1912–1925, Paris) established a method of informing the world of fresh developments in fashion. Fashion pictures played a dominant role in such magazines; many new artists such as Paul Iribe and Georges Lepape caused this era to be known as the golden age of fashion illustration. Poiret was the first to use the fashion catalogue as a medium for individual designers to display their work to the world, publishing *Les Robes de Paul Poiret by Paul Iribe* (1908) and *Les Choses de Paul Poiret* (1911), illustrated by Georges Lepape.

Because buyers and fashion journalists from many countries subsequently began to crowd into Paris to obtain information on the latest fashions, the Chambre Syndicale de la Couture Parisienne was set up in 1910 to control the scheduling of collections and prevent the proliferation of unauthorized, imitation merchandise. Paris was then well on the way to establishing a system to maintain its dominance as the fashion center of the world.

The outbreak of World War I in 1914 halted much activity in the fashion world. Women, who found themselves taking on the responsibility of men's tasks in society and industry during the War, needed practical clothing rather than decorative and elaborate costumes. Simple designs and shorter skirts were in demand, and tailored clothing fit the bill. The functional tailored suit became an essential women's fashion item of the time. In contrast to the dramatic changes in women's clothing, men' s fashion saw only minor alterations, such as a slightly looser fitting jacket and narrow hemlines on trousers, both created to permit greater freedom of movement.

New Women

Although they lost their jobs when men were discharged from military service after World War I, nothing could turn back the tide for women who had acquired a taste for the excitement of the outside world. Jazz became popular. A dance craze for the tango and the Charleston boomed. Everyone seemed to be racing around in high-speed automobiles, getting suntans, and swimming. New rules were applied to a society that now included a burgeoning *nouveau riche* class alongside the old-money upper class, and an avant-garde sensibility alongside traditional ideals of elegance. Caught up in the dynamic energy of the time, the cycle of fashion trends grew shorter.

Female looks changed significantly. Hairstyles went from full, upswept arrangements to short bobs. Hemlines shot up from below the ankle to flirt with the knee. Since a youthful, slender style found more favor than a mature and voluminous one, women accordingly dressed up like boys. *La Garçonne*, from the eponymous novel by Victor Margueritte (1922), was the symbolic image that women aspired to achieve. The new woman acquired a higher education, had a profession, and enjoyed romantic relationships without hesitation. She led society into new customs such as driving cars, playing golf and tennis, exercising, and even smoking.

The androgynous *garçonne* style, which eschewed any emphasis of the bosom or the waist, achieved general recognition at the Exposition Internationale des Arts Décoratifs et Industriels Modernes held in Paris in 1925, the exhibition that gave the style known as Art Deco its name. A short hairstyle with a close-fitting cloche hat and a loose fitting drop waist dress with a knee length skirt characterized the *garçonne* look. The extreme simplicity of the dress was supplemented with surface decorations of spangled embroidery, a feather boa, and assorted bright accessories. Underwear consisted of a brassiere, teddy, and natural flesh-tone stockings; makeup included red lipstick, white powder, and blush; eyebrows were plucked into a fine line, and the eyes were accentuated with a dark line of kohl to complete the look.

With the boyish bent of the period, it was only natural that a demand for sports clothing emerged. French tennis champion Suzanne Lenglen also helped to foster the production of sports clothing by demonstrating her matchless strength in functional tennis wear. The bathing suit, exposing more of the body than ever before, appeared on beaches everywhere in the late 1910s. Beachwear was also introduced, and the fashion of wearing pants became popular at resorts.

Gabrielle ("Coco") Chanel played a decisive role in this new aspect of women's fashion. She designed clothing for comfort, simplicity, and chic appearance with an innovative combination of jersey material and shapes borrowed from men's clothing. After her jersey dress caused a sensation, she designed cardigan ensembles, sailor-style "yachting pants," beach pajamas, and the renowned must-have item, a simple black dress. Another of Chanel's contributions to fashion was the idea that fashionable, ostentatious costume jewelry could represent real wealth as surely as jewels. The perfect embodiment of both the *garçonne* style and the independent woman, Chanel created a whole new dress ethic and proposed a style for women who were ready to pursue their own active lives.

In the golden age of *haute couture* during the 1920s and 1930s, many rising names in fashion design such as Jean Patou, Edward Molyneux and Lucien Lelong actively worked alongside the older established houses of Paquin and Callot Soeurs. Female designers were especially influential, and in the 1920s Chanel and Madeleine Vionnet played the most important roles. While Chanel's role was that of a media-savvy stylist, Vionnet was more an architect of fashion. Her technique of cutting garments from geometrically patterned fabric with a superb sense of construction brought about genuine innovations in dressmaking. Vionnet invented a wide variety of detailed designs like the bias cut, circular cut, cut with slash or triangular insertion, halter neckline, and cowl neckline. Inspired by the plain construction of the Japanese kimono, she also created a dress constructed from a single piece of cloth.

The association between fashion and art gained an unprecedented intimacy in the 1920s. Designers teamed up with artists for inspiration. New movements in art like Surrealism, Futurism and Art Deco proposed that the entire living environment, including clothing, should be harmonized as a single artistic manifestation. Collaboration with avant-garde artists, and the influence of Surrealism and Futurism in particular, brought radical artistic design to clothing. The decorative accessories and textiles of Art Deco emerged from this rich collaboration, which included the adaptation of a number of artistic techniques such as Oriental lacquering.

But the Great Depression of 1929 brought an end to much of the postwar prosperity enjoyed during the 1920s. Many of *haute couture's* wealthy clients lost their assets overnight, and the streets thronged with homeless people. The middle classes who survived the worst of the period became much more interested in sewing at home.

Art and Fashion

These difficult economic circumstances meant that the abstract and straight silhouette favored in the 1920s gave way to a more natural form in the 1930s. The slim line of clothing remained, but the bosom was reasserted and the waistline was once again nipped into a standard position. Long dresses came back for eveningwear and hair regained a more traditional feminine length with a soft curl.

But not everything regressed. Day to day clothing continued to feature practical dresses with short skirts, and increasingly popular items of sports clothing. The rich spent long periods of time at resorts and common people also enjoyed vacations at the beach. As a result, fashion for outdoor activities gained in importance. Although the term *prêt-à-porter,* or "ready-to-wear," had yet to appear, *haute couture* houses had started to move in that direction by including sweaters, pants and bathing suits for sports in their boutiques.

Elsa Schiaparelli started her career as a designer of sportswear like sweaters and beach clothing. She gradually expanded her line to include town wear and evening dress, and established herself as one of the most important designers in the 1930s. Schiaparelli is known to have employed great wit to create her unique fashions, epitomized by the famous black woolen sweater with a *trompe-l'œil* white bow that launched her career in fashion.

Schiaparelli was the designer who most closely worked with artists during her time. She was influenced by Dadaism, and adopted ideas from Surrealism for the creation of her eccentric dresses and hats. But art for her was not simply a source of inspiration; she also integrated it directly into her designs. Original sketches by Salvador Dalí and Jean Cocteau were printed or embroidered on her dresses. She eagerly exploited new materials and experimented with rayon, vinyl, and cellophane. However, her intentions did not extend to reshaping clothing itself, and no dramatic new silhouettes figure in her work. The square shoulder and marked waist characteristic of her designs were the mainstream fashion in the 1930s, and remained the dominant style during World War II.

During the 1930s, such female designers as Gabrielle Chanel and Madeleine Vionnet, who had enjoyed international acclaim since the 1920s, as well as Schiaparelli, represented the vanguard of the fashion world. But a male designer, Cristobal Balenciaga, opened his Paris salon in 1937, offering designs with a completely modern structure that garnered much attention.

American films exerted a powerful influence on fashion during the 1930s. Famous Hollywood stars like Marlene Dietrich and Greta Garbo wore dresses made by costume designers such as Adrian. These costumes looked relatively conservative and simple in cut compared to *haute couture* fashion in Paris, but they appeared magnificent on the screen because of their luxurious fabrics. The number of women in the

general public who watched Hollywood films – with an eye out for fashion tips – gradually exceeded the number who read fashion magazines featuring Paris *couture*.

Photography, invented in the nineteenth century, grew in importance in fashion magazines. Fashion photos appeared in magazines at the turn of the century, and as the quality of images improved, they became more prevalent. Photographers like Adolphe de Meyer in the 1910s and Edward Steichen in the 1920s are credited with the invention of fashion photography. In the 1930s, when color photography first appeared, the key images in fashion magazines became photographs rather than paintings or drawings. Through the efforts of many photographers, individual expression thrived; George Hoyningen-Huene and Horst P. Horst expressed modernity with sharp images; Toni Frissell pioneered outdoor photography under natural light; Man Ray and others experimented with the various possibilities of photography techniques.

World War II and Fashion

The outbreak of World War II in 1939 caused significant damage to the Parisian fashion scene. Many *couture* houses were forced to close and the few salons that remained open suffered a shortage of material and the flight of clients. The intention of the Germans was to transfer the entire fashion industry from Paris to either Berlin or Vienna. The fashion industry found itself under great pressure in Paris, and Lucien Lelong, the president of the Chambre Syndicale de la Couture Parisienne, went to great pains to try to maintain the status quo of Parisian fashion under the Occupation. In 1940, The Limitation of Supplies Order was enforced. This order regulated the quantity of cloth to be used in clothing manufacture, so that a single coat for example could use no more than four meters of material. Coupons were necessary to purchase rayon, which was one of the few materials available during the time. Many people had to make do with refashioning their own old clothing at home.

In England, The Incorporated Society of London Fashion Designers was commissioned by the British Board of Trade to create a range of prototype clothing to meet the requirements of the Utility Clothing Scheme, enforced in 1941. Thirty-two types of Utility garments designed by Edward Molyneux, Hardy Amies and Norman Hartnell among others, were selected and mass-produced. The United States entered the war in 1941, and the following year, the U. S. War Production Board issued General Limitation Order L-85, which regulated clothing in minute detail, stressing conservation of fabric; the slim and straight skirt without pleats was encouraged, and the flared skirt was completely forbidden.

Because of the shortage of material and the strict rationing systems, the slim silhouette with a skirt of shorter length became dominant in fashion. With the world's attention drawn to those engaged in military service and national defense, an interest in military fashion developed. The look of the time embraced uniform-styled tailored suits and jackets with square, padded shoulders, a pronounced waist with a belt, and large versatile pockets. Since materials for making hats were not rationed, large hats and turbans in bold designs became characteristic of the period, as did platform shoes with cork soles that emerged as an answer to the shortage of leather.

The decline of Parisian fashion brought about the rise of American fashion. The United States, which had been the most important client for Parisian *haute couture* before the War, developed its own fashion industry at a comfortable distance from the fighting in Europe. Although the United States had its own *haute couture*, before the war it had relied on Parisian houses for high quality and elegant clothes. The field in which the United States was first to make its mark was not, however, in high fashion, but in casual wear for daily use and ready-to-wear clothing.

From the mid-1930s, a distinctively casual Californian style, a New York business style, and a functional, less expensive campus look all began to draw attention. The decline of Parisian fashion authority stimulated American fashion designers to be more creative and active. Claire McCardell, with her free sense of inspiration, designed a line of practical and innovative sportswear with simple construction in cotton or wool jersey. Backed by a powerhouse of similar American designers, the basis of American style, a style which pursued functional beauty, was established.

After the Liberation of Paris by the Allied Forces in June of 1944, the Paris fashion industry immediately resumed activity. *Haute couture* started to show collections again, and new designers such as Jacques Fath and Pierre Balmain made their debut. In 1945, the *Chambre Syndicale de la Couture Parisienne* planned the "*Théâtre de la Mode,*" an exhibition of miniature mannequins seventy centimeters high, dressed in *couture* clothing from new collections. The exhibition, intended to display to the world the breadth of French culture and creativity in fashion, accomplished its purpose through a yearlong tour of nine cities around world. In 1947, Christian Dior launched his first collection, "The New Look," which had palpable impact on the world of fashion. The result was that *haute couture* regained a dominance in world fashion that surpassed even that of the prewar period. It is interesting (and ironic) to note that women were highly appreciative of the nostalgic "New Look" style – a narrow waist cinched with a corset and a full and long skirt – as they simultaneously achieved various freedoms and civil liberties, including suffrage.

Reiko Koga, Professor at Bunka Women's University

Hats were elaborately decorated in the early twentieth century. As hats became bigger, light-weight feathers were abundantly used. Hats decorated with whole stuffed birds became popular, threatening beautifully plumed species with extinction. A chorus of public criticism resulted, and in the United States, regulations were brought in to prohibit the killing, importing and selling of wild birds.

↓ **Anonymous**
Hat
1900s

Beige silk tulle with cotton lace; ornamentation of cotton tulle; buckle and ostrich feather.
Inv. AC1726 78-41-130

→ **Anonymous**
Hat
1905–1909

Straw hat with black velvet ribbon and stuffed bird.
Inv. AC4667 83-26-8A

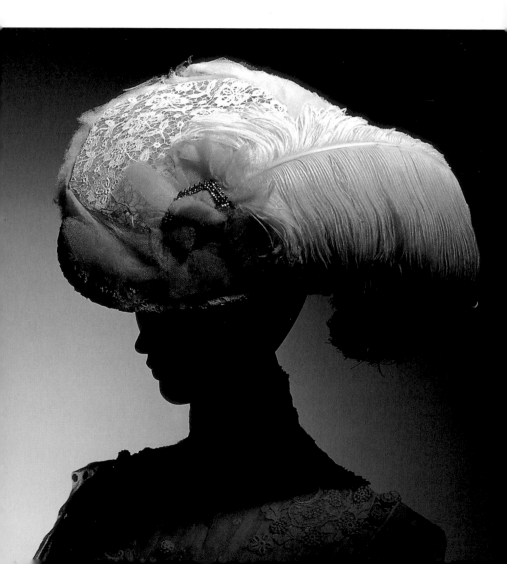

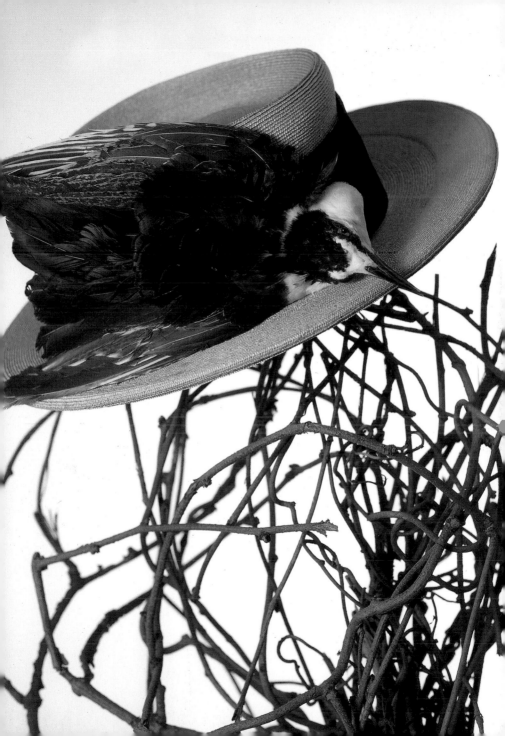

Poiret introduced the corset-free, high-waisted dress in 1906, when the S-curve-silhouette dress was still popular, thereby suggesting the shift from the ostentatious artificial forms of the nineteenth century to a revolutionary style that brought out the natural beauty of the body. The result was a great transformation in fashion. Although the corset did not disappear overnight, by the time of World War I Poiret's new style had totally supplanted the corset.

Orientalism was prevalent in Paris after the debut of the Ballets Russes in 1909. In 1911, Poiret held a fancy dress ball, *La 1002ᵉ nuit* where he showed his collection inspired by the Orient. The designs were adopted from the ethnic costumes of various Eastern countries such as India and China. The party was such a success that Poiret became known as a forerunner in dramatic and exotic fashion design. His dresses were illustrated in *Les Choses de Paul Poiret* by Georges Lepape.

→ **Paul Poiret**
Man's Party Costume
Label: PAUL POIRET-a Paris-Mars 1 1914

Gold lamé and purple silk satin jacket with fake pearls and black fur; kimono sleeves; gold lamé hat with fake pearls and aigrette plume.
Inv. AC9175 94-40-2AB

→→ **Paul Poiret**
Woman's Party Costume
Label: PAUL POIRET-a Paris-December 1913-31890 1913

Black silk gauze hooped over-dress with gold floral embroidery; gold lamé silk harem pants.
Inv. AC9330 96-15

Party costumes by Paul Poiret
Photo: Mario Nunes Vais

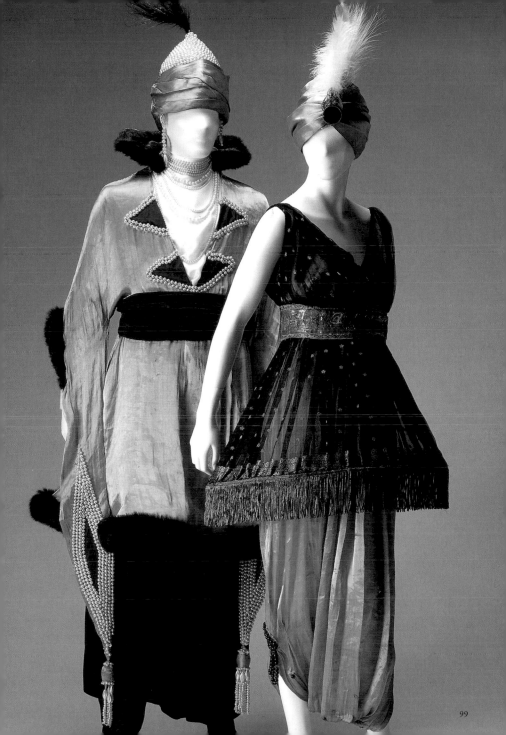

This dress was an interpretation of a Japanese kimono style by a Western designer. The influence of the Japanese kimono may be observed around the collar, the front neck opening in *uchiawase* style, and the straight-cut "kimono sleeves." The round cut from front slit to train evokes the beauty of a trailing kimono. The design of the embroidery and the style of the back of the dress demonstrate a Chinese influence as well.

Callot Sœurs
Evening Dress
Label: none
c. 1908

Black and purple silk charmeuse pieced together; *chinoiserie* floral embroidery; ribbons from shoulder stitched at back waist; tassels at ends.
Inv. AC7708 93-2-1AB

Woman in Beer's *forme Japonaise* dress
Photo: Paul Boyer
Les Modes, February 1907

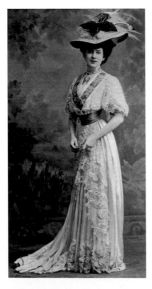

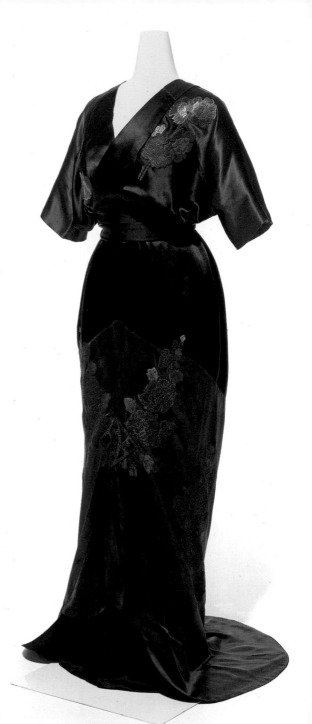

Worth
Coat
Label: Worth
c. 1910

Dark red velvet; kimono neckline;
looped *kumihimo* (Japanese cord)-
like decoration; tassel with beading.
Inv. AC2880 79-27-1

Woman in Beer's Afternoon dress
Photo: Félix
Les Modes, May 1910

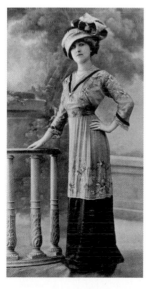

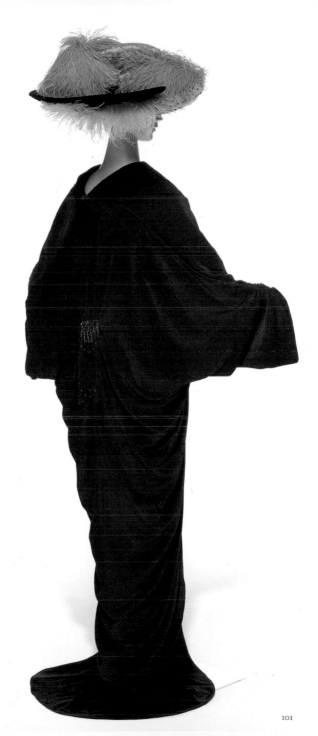

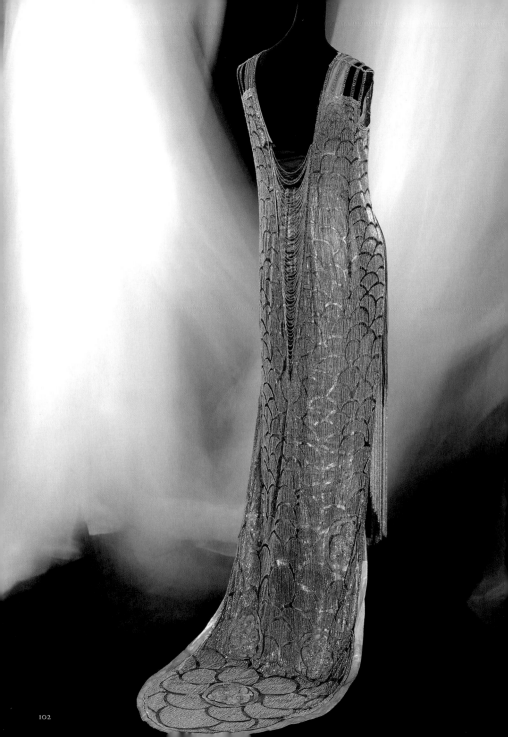

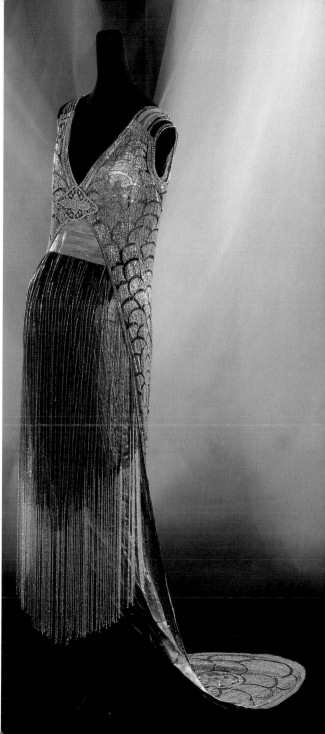

In this dress, Japanese *yotsukanawa* and *seigaiha* motifs are depicted on the train with metallic beads. The *seigaiha*, literally "blue ocean wave" in Japanese, represents a wave in China and a scale in Western Europe. This geometric design was often used in the Art Deco style, which was dominant in the 1920s. The almost-straight silhouette hinted at the Art Deco style, which was soon to become a trend.

Beer
Evening Dress
Label: Beer, 7 Place Vendôme, Paris
c. 1919

Black net with silver bead and rhinestone embroidery of Japanese traditional motifs; silver bead fringe; sash in green and gold stripes; silver lamé underdress.
Inv. AC7683 93-1

Japanese family crests from a book by T. W. Cutler, *A Grammar of Japanese Ornament and Design*, 1880

Mariano Fortuny was a versatile artist who showed talent in various fields such as painting, photography, stage design, lighting, textiles and clothing. "Delphos," his classical Greek-inspired pleated dress, dates from around 1907, and it is one of his most famous designs. The fine silk pleats flow from the shoulder and gently surround the body. This modern and body-conscious form was a clear indication of new directions in twentieth-century fashion. The pleats, which change color in accordance with movement and the reflections of light, are dazzling, and their timeless beauty still remains striking and influential today.

Mariano Fortuny
"Delphos" Dress
Label: none
1910s

Topaz-colored silk satin one-piece dress; thin pleats all over; glass beads at armholes and side seams.
Inv. AC5157 85-34-2

Pages 106/107
Mariano Fortuny
Tunic
Label: none
1910s

Black silk gauze stenciled with gold Islamic pattern; glass beads.
Inv. AC5075 85-8-1

Chanel thought that it was crucial for women's clothes in the twentieth century to have functional features. Discarding superficial decoration and adapting the essence of men's fashion, she created sporty, functional women's fashion that brought a new type of elegance. A working woman herself, Chanel embodied the "*garçonne*," the new model image of women after World War I, and wore her own creations.

In 1916, Chanel designed cardigan suits made of wool jersey, which at the time was a fabric mainly used for underwear. This style, completed with elastic materials and a shorter skirt in a simplified silhouette, later became a prototype for the "Chanel suit." The dress on the right is an example of a cardigan suit from the 1920s. The knee-length skirt in simple silhouette and monotone colors makes the dress look modern. The carnation corsage is attached to the dress, although later on the camelia corsage was the one always applied to Chanel suits.

→ **Gabrielle Chanel**
Day Ensemble
Label: CHANEL
c. 1928

Jacket and skirt in black wool crepe without lining; white wool jersey sweater.
Inv. AC6301 89-9AC

Chanel wearing her wool jersey cardigan ensemble, 1928

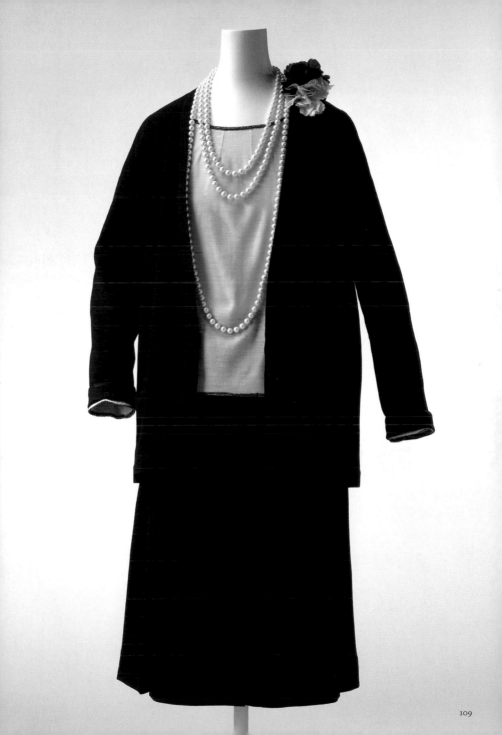

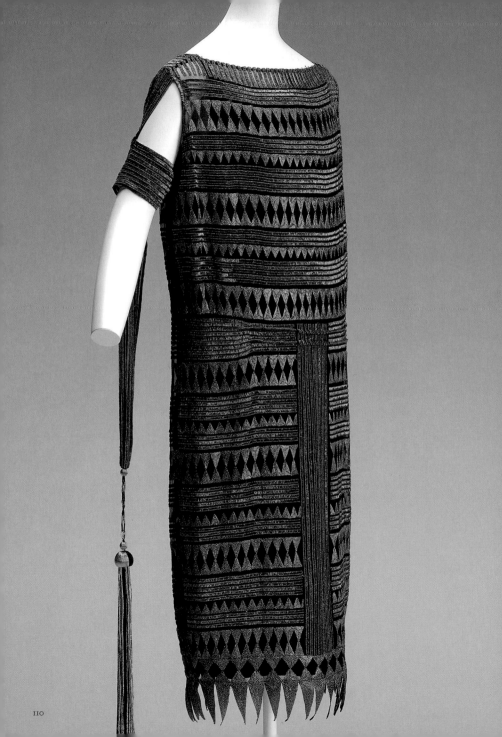

The exoticism of the 1920s was influenced by the many cultures that had reached Western Europe: Orientalism that had continued on from the 1910s, an Egyptian style spurred by the discovery of Tutankhamen's tomb (1922), and the Mexican craze influenced by Aztec art. Exotic influences are easily discernible in the fashion of the time. Vionnet introduced a classical Greek-inspired design in 1924; this dress was embroidered with gold thread using a similar technique, but depicts an Egyptian geometric pattern.

Thayaht
Vionnet's dress
La Gazette du Bon Ton, 1924

.THAYAHT.
2/4

Madeleine Vionnet
Evening Dress
Label: none
1927

Black silk gauze with gold thread embroidery; Egyptian geometric pattern; strap with tassels.
Inv. AC6815 90-24-3

ROBE TISSÉE POUR MADELEINE VIONNET

Poiret was a great eclectic creator. His oriental taste may still be observed in a coat of the 1920s.

Paul Poiret
Coat
Label: PAUL POIRET a Paris Mai 1923
33887
Spring, 1923

Dark rose silk jacquard with floral pattern; collar, yoke and sleeves of purple silk satin with gold embroidery; dolman sleeves.
Inv. AC2798 79-23-11

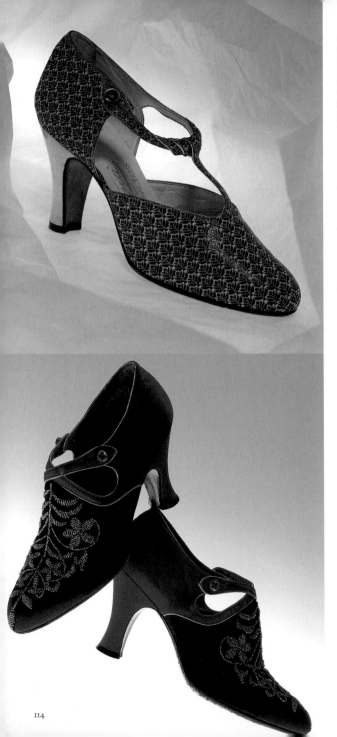

Skirt-lengths rose up to the knee and shoes played an important role in the fashion of the 1920s. Because of this trend, shoe designers who functioned differently from conventional shoe craftsmen became active. Perugia gained his fame making shoe designs for Poiret, and he was most active from the 1920s to the 1940s.

← **André Perugia**
Pumps
Label: Perugia BTÉS. G. D. G.21 AVEN. DAME.NICE 11.FAUBG ST HONORÉ PARIS
1920s–1930s

Above: silver and lamé brocade; t-strap; buttons.

Below: red and black silk satin; floral embroidery of metal beads; buttons.
Inv. AC8948 93-33AB, AC9039 93-50-1AB

↗ **Anonymous**
Heels
c. 1925

Wooden heels with enamel and resin paint; decorated with inset rhinestones.
Inv. AC7766 to 69 93-80-7AB to 10AB

→ **Faucon**
Evening Bag
Label: FAUCON 38 AVE DE L'OPÉRA PARIS
1910s

Gold lamé and black leaf-motif damask; brass frame with gilding; strap of silk cord; pocket.
Inv. AC4819 84-13-5AB

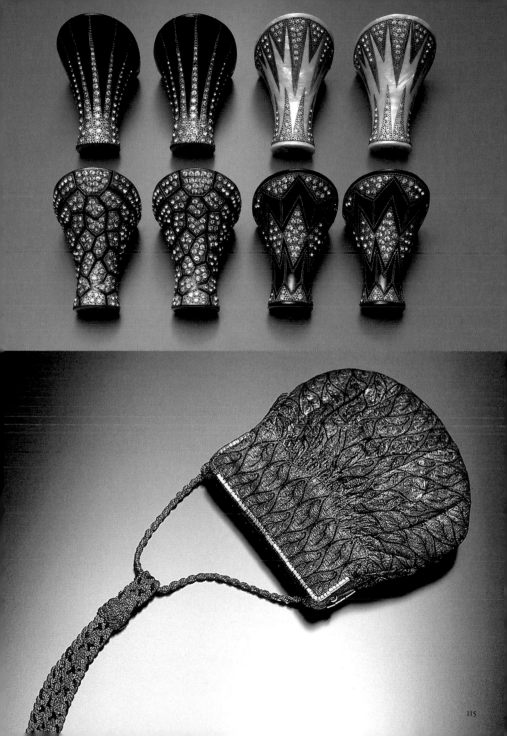

Twentieth-century fashion moved in a totally new direction. After World War I, the corset, which had constricted the female body for so long, was completely abandoned. The brassiere then replaced the corset as the supporting undergarment. The brassiere was more suitable for the free and active fashion of the *garçonne* in the 1920s, because of its less restrictive structure and flat silhouette. The slip, another piece of contemporary underwear, was also invented around this time to suit the one-piece dress then in fashion.

↑ **Anonymous**
Brassiere
1920s

Pink silk georgette with lace insertion; flower ornament.
Inv. AC1586 78-40-37

→ **Anonymous**
Chemise
1920s

Blue crepe de Chine with lace insertion.
Inv. AC1532 78-39-64

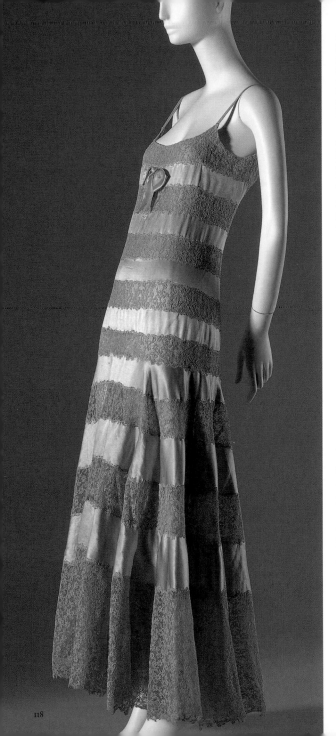

Chanel had a striking impact on fashion from the 1910s, adopting an underwear material, wool jersey, for *haute couture* dresses. On the left, this elegant evening dress from the 1930s has an insertion of lace, which was frequently used for lingerie during the Belle Epoque period.

← **Gabrielle Chanel**
Evening Dress
Label: CHANEL CANNES-31,
RUE CANBON PARIS-BIARRITZ
c. 1930

Beige silk satin and lace; pieced alternately.
Inv. AC4479 83-11-15

With the growing popularity of sports in the 1920s, the pajama as beachwear became fashionable. The pajama, which had been worn as men's sleeping wear, was adapted for women's beachwear and hostess dresses on informal occasions and at resorts. The culotte dress on the right has elements of the pajamas created in the 1920s. The black lace pattern looks intricate over the pink underdress.

→ **Madeleine Vionnet**
Culotte Dress
Label: MADELEINE VIONNET
DÉPOSÉ
1937

Pink silk chiffon culotte dress; overskirt of black net with lace appliqué; velvet bow; undergarment of crepe de Chine.
Inv. AC6817 90-24-5AB

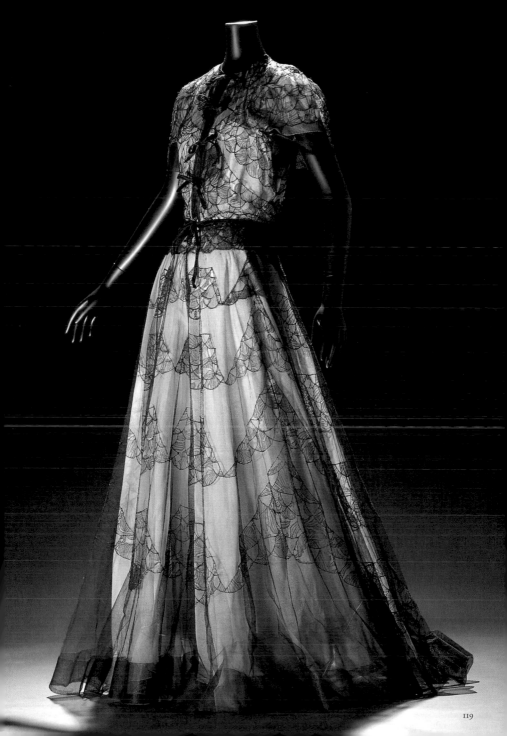

The elaborate long dress came back
into fashion in the 1930s, despite the
serious social conditions caused by the
Great Depression of 1929. Since Lan-
vin always kept her very elegant
design line, she was very much in tune
with the atmosphere of the 1930s.
These two dresses made by Lanvin
exhibit the silhouette typical of the
1930s. The dress on the right has
detachable sleeves. The shimmering
velveteen brings out its beautiful line.
The dress on the left, of mermaid line,
shows Lanvin's fine technique which
enabled her to give an impression of
lightness in spite of the long train.

← **Jeanne Lanvin**
Evening Dress
Label: Jeanne Lanvin Paris UNIS
FRANCE ÉTÉ 1934
Summer 1934

Black linen organdy; plaid pattern
with paillette embroidery; underdress
of crepe de Chine.
Inv. AC7583 92-17-17

→ **Jeanne Lanvin**
Evening Dress
Label: none
Autumn/Winter 1937

Black velveteen; bow on sleeve;
wrapped buttons on back opening,
sleeves and strap-neckline.
Inv. AC5551 87-14AD

Christian Bérard
Vogue (American), September 15, 1937

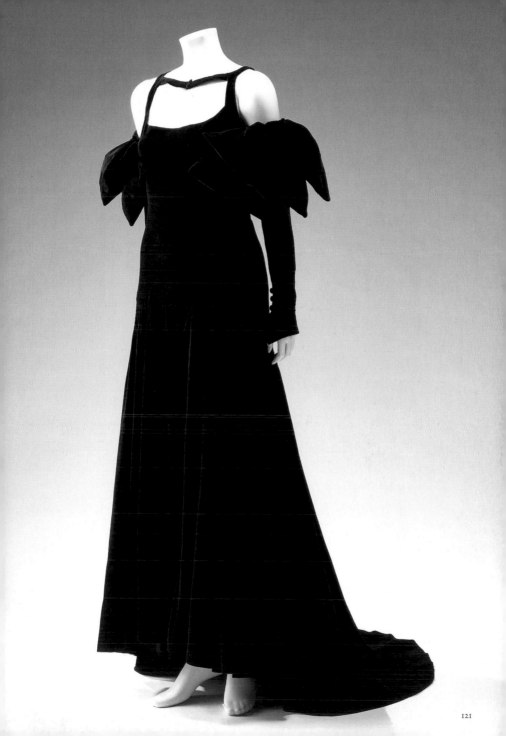

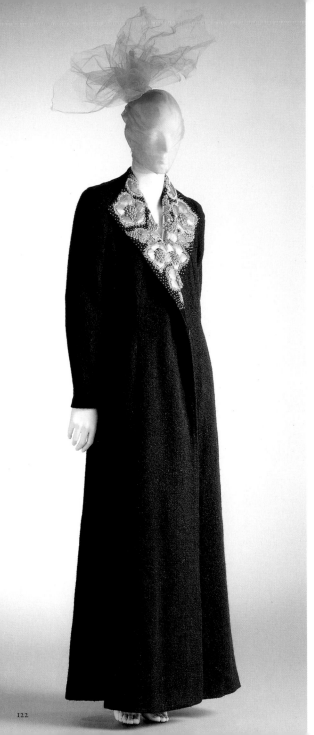

Elsa Schiaparelli led fashion in the 1930s with a keen eye on new developments in the arts and in technology. She worked closely with Dadaist and Surrealist artists, and tried to use the artificial materials that were being newly produced.

Schiaparelli was the first designer who used a zipper for a haute couture dress in 1935. This coat also has a zipper inside.

Elsa Schiaparelli
Evening Coat
Label: Schiaparelli London 4136
Autumn/Winter 1936

Wine-red wool; collar of velvet appliquéd with gold leather and beads.
Inv. AC7681 93-1-3

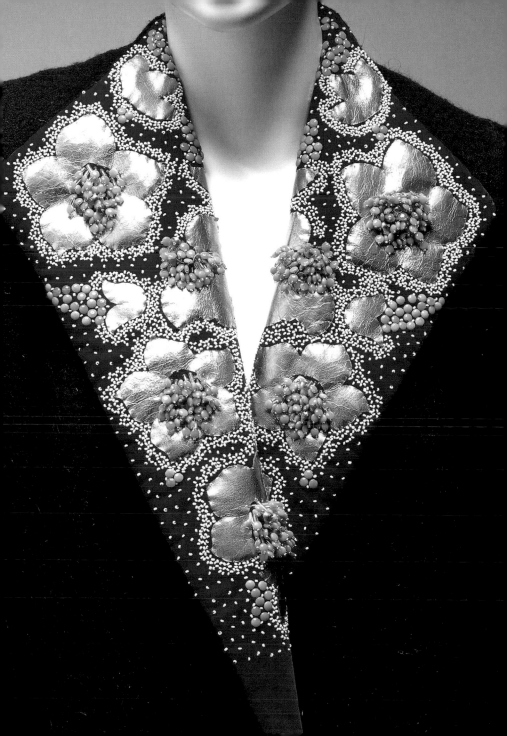

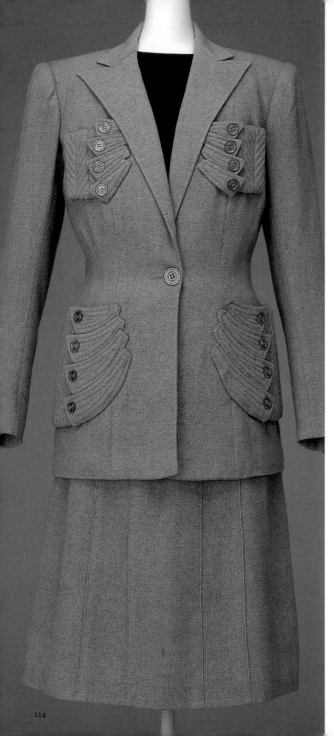

In 1944, Paris was freed from the Occupation. Many Parisian fashion houses had closed or moved to other cities during the war, and few remained. The serious shortage of materials had entailed a massive curtailing of production. The pre-war style of square padded shoulders and a slim line remained fashionable during the war, as this suit demonstrates. Lanvin took pride, as an established *haute couture* house, in producing the highest quality creations even in a regulated time, as may be observed in the elaborate quilting work and the beautiful seams of the skirt.

Jeanne Lanvin
Day Ensemble
Label: JEANNE LANVIN PARIS 22 Frg
St HONORÉ
1940–1944

Set of jacket and skirt; beige-pink wool tweed; quilted pocket with buttons.
Inv. AC4786 84-4-6AB

Page 126, left
Anonymous
Hat
1940s

Black aigrette feathers with comb.
Inv. AC5428 86-31-11

Page 126, right
Anonymous
Hat
1940s

Brown aigrette feathers with comb.
Inv. AC5429 86-31-12

Page 127, left
Marthe Schiel
Hat
Label: Modes Marthe Schiel 13, LOWER
GROSVENOR PLACE S. W. I.
1930s

Black felt with feather-shaped ornaments in leather.
Inv. AC1771 78-41-175

Page 127, right
Anonymous
Hat
1930s

Black silk faille with matching ribbon; white fur.
Inv. AC1770 78-41-174

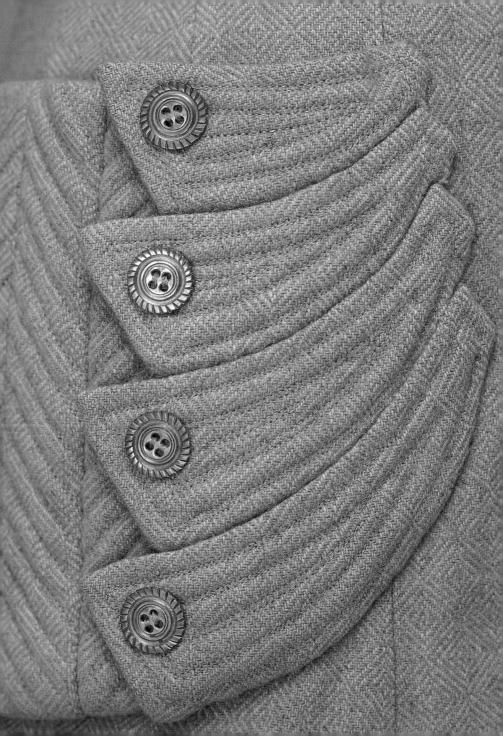

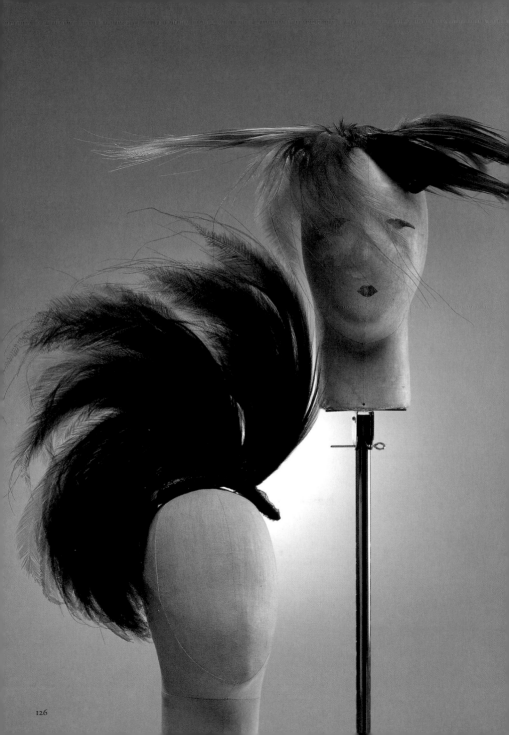

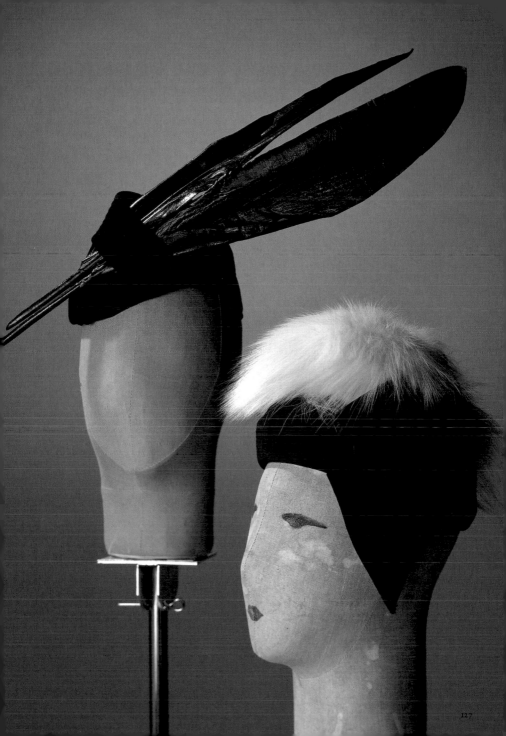

20th Century · Second Half

After the confusion caused by the aftermath of World War II in the 1950s, society entered an era of mass consumption in the 1960s. The dynamics of mass production were everywhere evident in the world of fashion. Perhaps best symbolized by space exploration, technological innovations proliferated, and this hastened the development of manmade fibers. As a result, reasonably priced and good quality *prêt-à-porter* (ready-to-wear) clothing came into existence.

Haute couture, the accepted fashion authority up to this point, no longer seemed to offer designs that fitted the ordinary and practical lifestyle of people in the new, post-World War II era. During the 1970s, as social aesthetics went through a drastic transformation, there was a demand for new clothing for the masses. *Prêt-à-porter* proposed everyday outfits for active, working women, and brought fashion to a new level of popularization. Street fashion also proved to be an important inspiration for the creation of *prêt-à-porter*.

From the 1970s on, *prêt-à-porter* made it possible for the fashion industry to develop and diversify. Paris had long been the capital of mode and refined craftsmanship, but now various cities joined the ranks and became thriving centers of distinctive new trends. The 1980s saw a return to traditional style, but in the 1990s, people began to consider the meaning of clothing once again, and to search for an idealistic system for the fashion industry of the twenty-first century. At the turn of the twentieth century, fashionable clothing could be seen, ordered, and sent anywhere in the world instantly thanks to media such as television and the Internet. Consequently, fashion at present appears to be headed toward a universal uniformity.

The Revival of Parisian Haute Couture

Parisian *haute couture* suffered much during World War II, but started work again when Paris was liberated from the Occupation in 1944. Although the war was over, confusion reigned, and people seemed unable to completely enjoy the peace.

It was Christian Dior who stimulated the Parisian *haute couture* revival. In February 1947, Dior's first collection was heralded as the "New Look," which determined the direction of fashion for the 1950s. The "New Look" was a nostalgic and elegant style, characterized by rounded shoulders, a high and emphasized bust, a tiny, cinched waist, a longish and bouffant skirt, gloves, a hat, and high-heeled shoes. To make a "New Look" dress required dozens of meters of fabric. For women, who had been forced to dress in a simple and austere manner during the Occupation, this luxurious use of material was confirmation of the fact that the war really was over. During the 1950s, Dior presented a consecutive string of new designs each season and his output had a tremendous impact on world fashion.

Spanish-born Cristobal Balenciaga was another great designer in the 1950s. Balenciaga was one of the few designers who had hands-on experience of dressmaking techniques, and he sought perfection in every snip and seam. Featuring creative silhouettes, a unique, extra space between the garment and body, and exquisite colors, his designs were so like artworks that Balenciaga became known as "The Master" of *haute couture*. Additionally, since his dresses did not require undergarments to mold the body, they were

renowned for comfort. His round-collared suit and slightly fitted, beltless tunic dress of the 1950s became the basis of female garments during the second half of the twentieth century.

In 1954, Gabrielle (Coco) Chanel, who had suspended her work during World War II, made a strong comeback. When women began once again to seek comfort as a respite from the nostalgic fashions of the 1950s, Chanel reintroduced the "Chanel suit," which was a perfected version of her 1920s cardigan ensemble. With their simple structure, functional Chanel suits found worldwide acceptance in the 1960s, and came to represent the style of the modern twentieth century, and this style of suit was later adopted in the international market of *prêt-à-porter* clothing.

Although Parisian *haute couture* was destined to become isolated from the demands of the emerging mass consumer society, it still produced many talented designers in the 1950s and 1960s. People came to appreciate once again the power of traditional *haute couture*, and fashion buyers and journalists from around the world gathered at collections held twice a year in Paris, which again became the fashion capital of the world. The economic infrastructure of fashion in France was much aided by the establishment of a licensing business to approve copyrights of *griffe*, or "brand label" clothing. This started an obsession with brand names that still holds an irresistible appeal to women today. In addition, regulated sales of legally sanctioned clothing patterns known as *toile* and a strong perfume industry helped bolster the Parisian fashion market.

Youth Power

In the 1960s, baby boomers reached their teens, and the era of mass production and mass consumption was in full swing. In 1961, the Soviet Union launched the first manned space flight, and in 1963, President John F. Kennedy was assassinated. The May Student Uprisings in Paris occurred in 1968, and the first landing on the moon was achieved in 1969. In the midst of such explosive drama, the young generation sought its own distinct mode of expression, and the powerful new American culture was an obvious choice. The voice of the young was heard in the lyrics of British bands like The Beatles and their concerns were portrayed in the French cinema movement of *Nouvelle Vague*. Fashion, too, took to presenting fresh and bold emotions.

The young found that displaying their physique was the most effective means of setting themselves apart from the older generation. In 1964, American designer Rudi Gernreich introduced the topless bathing suit, the "monokini," which clearly represented a new concept of the body: a "body consciousness." A dress exposing the legs up to the thighs was tagged the "mini," and proved a simpler and more practical method to express the same concept. Bare legs in women's fashion, which also appeared in the 1920s, developed through various conceptual stages in the 1960s. Marshall McLuhan insisted that clothes were an extension of skin, and Yves Klein expressed his thoughts in his artwork "Anthropometry." London designer Mary Quant also played a hand in bringing the "mini" into the world of fashion and into acceptance as a normal style of the twentieth century. The same can be said of André Courrèges' minidresses, displayed against the powerful background of Parisian *haute couture*.

Before the shock waves created by the mini-skirt had subsided, a women's pants style came into its own in the world of fashion. Although the *garçonne* style of post-World War I had introduced an androgynous look featuring tailored jackets as a form of women's fashion, trousers at that time were meant to be worn only indoors or on the beach. In the United States, jeans, clothing originally designed for manual labor, became casual attire for both men and women in the 1930s. Then, after World War II, trousers found acceptance as women's casual wear. The trend influenced high fashion, and when Courrèges presented a pants-style evening ensemble in Paris in 1964, the taboo on pants for women in *haute couture* was finally broken. Pantsuits became the talk of the town.

Dresses also caused a stir. In his 1964 Space Age Collection, Pierre Cardin unveiled designs for future-oriented dresses shaped in simple geometric patterns and made of inorganic materials. Making his debut in *haute couture* in 1953, Cardin buried the classical elegance of 1950s fashion, but his minimal clothing was more in sync with the soon-to-be thriving *prêt-à-porter*. In 1959, Cardin presented his *prêt-à-porter* line for the first time as a member of the *Chambre Syndicale*, the monitoring body of *haute couture* in Paris. From this position of strength, he was able to pioneer the system of a ready-to-wear business operated by an *haute couture* designer house. Moreover, in 1960, he broke into the field of men's clothing, which up until then had been the closely guarded purlieu of tailors in a system that had remained largely unchanged since the French Revolution. Cardin anticipated the arrival of the "unisex" trend, a powerful shift in sensibility that fed into the hippie movement. By the late 1960s, men wore their hair long and donned brightly colored clothing with lace and frills, earning this period of fashion the apt sobriquet the "Peacock Revolution."

Yves Saint Laurent, a standard-bearer among young designers, was also extremely sensitive to social trends. He became independent from the House of Dior in 1961, and opened a *prêt-à-porter* boutique named Saint Laurent Rive Gauche in 1966, introducing a line of women's tailored pants for city wear. The May Student Uprisings in 1968, which had a profound impact on French social values, also contributed to the spreading popularity of the pants style. In yet another move which fell in step with the times, Saint Laurent created a manifest fusion of fashion and art in two of his dresses, the "Mondrian Look" in 1965 and the "Pop Art Look" in 1966.

New manmade materials opened up various possibilities for minimal fashion in the trendy futuristic and synthetic styles of the 1960s. Although Elsa Schiaparelli had experimented with manmade fibers in clothing from as early as the 1930s, her attempts had been regarded as radical anomalies. In the world of *haute couture*, Paco Rabanne debuted sensationally in 1966 with a dress constructed almost entirely of plastic. It was Rabanne who first systematically moved beyond the idea that only fabric could be used to make garments, and he continued to adopt metal and non-woven materials for clothing.

The reliability of mass-produced manmade fibers supported the development of the ready-to-wear industry. In 1935, Dr. W. H. Carothers invented nylon, the first manmade fiber, at the DuPont Company in the United States. In 1940, the company launched nylon stockings, which quickly became enormously popular. Further manmade fibers for clothing were soon introduced. Imperial Chemical Industries (ICI) put polyester on the market in 1946, and DuPont developed stretchable Lycra in 1958. In the early days, manmade fibers were thought of as an inexhaustible and inexpensive substitute for costly natural materials, but in the mid-twentieth century, synthetic fabrics also began to be appreciated for their various superior functions and their unique textures.

The Rise of *Prêt-à-Porter* (Ready-to-Wear) Clothing

In the 1960s, *haute couture* still controlled the trends of world fashion, but the age of the mass-consumer society was fast approaching. *Prêt-à-porter* arrived to meet the needs of a large market with good quality products. Ready-to-wear clothing had been available since the end of the nineteenth century, but it was considered cheap and poorly made. In the twentieth century, with the advance of mass culture and manmade materials, *prêt-à-porter* gained respect and popularized fashion. In 1973, *prêt-à-porter* designers started showing collections in Paris twice a year, following a similar schedule to *haute couture*. Such collections have been held in Milan and New York since the mid-1970s, and London, Tokyo, and other cities were not slow to follow. The Paris-centered fashion system founded by Charles Frederick Worth at the end of the nineteenth century clearly still plays a crucial role today.

Designers such as Sonia Rykiel and Emmanuelle Khanh introduced *prêt-à-porter* clothing that was stylish as well as suited for everyday life. Another influential designer, Kenzo Takada, made his debut in Paris in 1970. His creations, made of common kimono textiles, appeared on the front cover of *Elle*. He soon became an advocate of *prêt-à-porter*, and he represented a counter-cultural aspect of the era by focusing on daily, relaxed designs and by using Japanese materials in unfamiliar ways.

In the 1970s, as if in a backlash against the futuristic fashions of the 1960s, trends returned to a natural look along the lines of Takada's designs. Hippie and folkloric fashion, including jeans, bloomed. Jeans, in particular, became emblematic of American prosperity, Hollywood movie stars, and rebellious youth. Triggered by the Vietnam War in the late 1960s, people everywhere began to reject the Establishment. Hippies disregarded traditional society and morals, and looked towards foreign cultures and religions for inspiration and enlightenment. Male and female hippies wore their hair long, handcrafted their own folkloric fashions, and favored worn-out jeans. Young people all over the world followed in their footsteps and nearly everyone, it seems, from student demonstrators to folk singers with their antiwar songs, wore T-shirts and jeans. Designers in Paris were not oblivious to this new trend and they presented folklore clothing and torn jeans as items of fashion. Enjoying unprecedented popularity, jeans became recognized as one of the first examples of clothing to cross all boundaries of generation, gender, class, and nation.

In the 1970s, in addition to the naturalistic style of hippies, street fashions added essential elements to the look of the decade. Yves Saint Laurent, while still in the House of Dior in the 1950s, started the then scandalous trend of adopting street styles for fashion when he borrowed the look of Parisian existentialists who gathered in cafes. The trends of mini-skirts and pants also arose from street culture. The hierarchy of the fashion world, which placed *haute couture* at the top of the pyramid, had already begun to collapse. From that time, the street fashions of punks, surfers, skaters, and almost anyone involved in the world of music or sport had a great influence on the look of the late twentieth century.

Power Dressing

By the 1980s, the world had grown more stable where politics and economics were concerned. Consequently, fashion returned to a conservative look. In 1979, Margaret Thatcher became the first female Prime Minister of England, and equality of the sexes as a moral goal gradually gained international attention. Women, suddenly active in the world of professional business and interested in keeping their bodies physically toned, wore a style called "Power Dressing" which simultaneously promoted an image of powerful authority and a soupçon of sexualized femininity. This trend included both conservative elements and a return to "body-conscious" fashion as seen in the 1960s. Azzedine Alaïa led the 1980s body-conscious style by using state-of-the-art stretch materials. Traditional Parisian houses like Chanel and Hermès regained status in the fashion world, meeting the more conservative needs of the time.

By the 1970s, the *prêt-à-porter* industry had developed in many countries. Milan, the center of Italian fashion, distinguished itself by anticipating trends through thorough market research. Giorgio Armani designed clothing for executive men and women, producing sophisticated tailored suits without interfacing or lining, and Gianni Versace drew international attention to Italian fashion in the 1980s with his luxurious yet practical "Real Clothing." Both designers established prestigious Italian fashion brands.

Compared to the clothing of the nineteenth century, which on the whole tended to be voluminous and ornamental, twentieth century apparel appears stripped-down and closer to the body. Indeed in the "body-conscious" era of the 1980s, items that would previously have been considered underwear surfaced as articles of outerwear. Avant-garde designers like the new wave Parisian designer Jean-Paul Gaultier and British Vivi-

enne Westwood transformed traditional lingerie, such as corsets and garter belts, into modern outer garments intended to express the dynamism of the human body. The adoption of traditional clothing as subject matter that is then inverted and presented as a modern creation can be described as post-modern in approach. Trends along these lines continued well into the 1990s.

Japanese Design

Japan gradually adopted Western clothing for daily wear during the Meiji Period (1867–1912), and caught the wave of world fashion after World War II. With the 1970 successful debut of Kenzo Takada in Paris, and supported by postwar economic prosperity, Japanese designers finally found themselves on the catwalks of international fashion.

Issey Miyake held his first show in New York in 1971 and in Paris in 1973. His significant concept, "A Piece of Cloth," highlighted the idea of a flat garment, which is the traditional structure of Japanese clothing. Miyake pointed out that covering the body with a single piece of cloth creates interesting "*ma*" (space) between a body and cloth. Because each person's figure is different, the "*ma*" is unique in each instance, creating an individual form. The concept radically differed from that held by Westerners. By the end of the 1980s, Miyake had designed a line of innovative pleated clothing. The usual process of making pleated clothing is to pleat the cloth first, then construct the article. By reversing this process and pleating the clothing after the cut-and-sew phase, Miyake created new artifacts that organically combine materials, shapes, and functionality. His innovative creations rest on the Japanese textile industry, whose strength is chemical engineering, as well as on the traditional Japanese approach to clothing, which emphasizes the material itself. In 1999, Miyake introduced "A-POC," which proposed an entirely new ethic of future clothing. Combining modern computer technology with traditional knitting methods, he created free-sized garments that arrive as a knit tube. The wearer cuts out the desired clothing shapes from the tube, thereby automatically customizing the ready-made clothing.

In 1982, Rei Kawakubo and Yohji Yamamoto had a startling impact on Western fashion. They showed monochromatic, torn, and non-decorative clothes, bringing shabbiness into fashion to intentionally express a sense of absence rather than existence. Kawakubo, ever unsatisfied with preconceived ideas, has continued to take on new challenges. Yamamoto, on the other hand, more in line with Western principles of clothing, has found his own signature by synthesizing European tailoring and Japanese sensibility. Finally, in the next generation of Japanese designers, Junya Watanabe has produced clothing that makes use of innovative cutting and the unique characteristics of manmade fibers.

Japanese designers have greatly influenced the world's young fashion designers by expressing, consciously or unconsciously, their Japanese aesthetic sense. Part of the reason for their strong impact on world fashion might stem from the suggestion implicit in their work that international clothing can come from a culture other than that of the West.

Diversification of Values

The Wall of Berlin collapsed in 1989, and the Soviet Union was dissolved in 1991. There is no doubt that the late twentieth century witnessed drastic changes in social systems. The fashion system, too, evolved smoothly into a gigantic industry, astonishing the world with remarkable progress through various communication technologies such as TV and the Internet. An infatuation with brands made people acknowledge that fash-

ion is far more than just things, but rather information in and about itself. At the same time, the deterioration of the global environment called into question the material culture of the fashion system. In response, people began to focus on used, recycled, or remade clothes as well as *haute couture* clothing that was not mass-produced. For instance, Belgium-born Martin Margiela, who debuted in 1989 in Paris, recycled his previous works and repeatedly presented the very same items in his shows. His approach expressed an objection to a fashion system that continuously creates new things and discards old ones. His proposal to recycle was widely applauded in the 1990s.

By the end of the twentieth century, in direct opposition to the previous century's finale, clothing had been stripped down practically to the bare body. Instead of then focusing on simplified garments, fashion began to regard the human body itself as the object to "wear." The ancient arts of body decoration – makeup, skin piercings, tattoos – reappeared as the latest fashion trend for men and women at the turn of the twentieth century.

That fashion may seem to repeat certain styles is inevitable because the shape of the human body limits options. However, the reemergence of past styles must each time be considered a completely new expression of the present age, as it arises from an entirely new social context.

The Kyoto Costume Institute (KCI) has attempted to reveal the dominant social circumstances and concerns in history through the study of clothing, which represents culture and the aesthetic aspect of history. A quarter of a century has passed since the KCI launched its collections and began its research on Western clothing. Through clothing, each scene of human history – the luxurious court culture, the awakening of the modern society, the evolution towards a mass-consumer society – appears clearly and tangibly. In the twenty-first century, we are sure that people will continue to express new ethics of beauty through clothing.

Rie Nii, Assistant Curator at The Kyoto Costume Institute

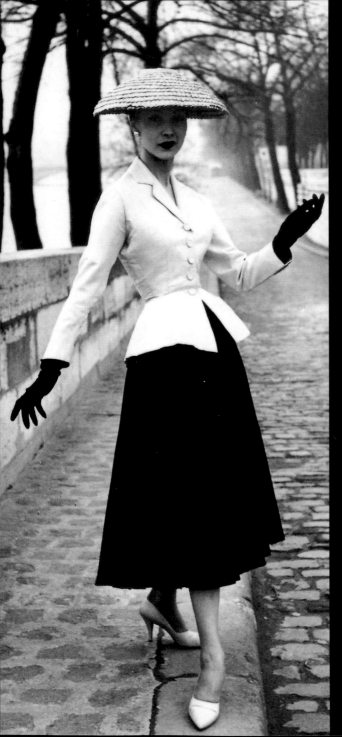

Christian Dior's nostalgic and elegant 1947 collection, which featured a soft rounded shoulder line, thin waist, and wide skirt was quite contrary to the austere style of World War II. This collection, an introduction to the era of peace that was to follow, became known as the "New Look," and gained worldwide success.

Shown here is a dress included in Dior's collection one season after this phenomenal debut, a collection considered to be the next stage in the "New Look" series. This is an extravagant day dress made with dark-colored velvet, against which the leopard skin stands out. The exotic fur blends well with the elegant shape, giving the dress a mysterious harmony.

→ **Christian Dior**
Coat Dress
Label: none
Autumn/Winter 1947

Dark green velvet; cuffs of leopard skin; gold thread, sequin and bead embroidery on bodice and pockets; black suede belt.
Inv. AC10431 2001-1-1AD

← "New Look" by Christian Dior, 1947
Photo: Willy Maywald

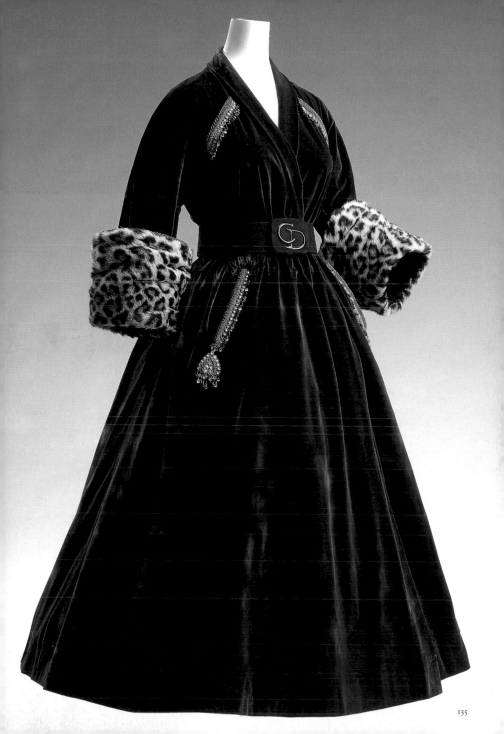

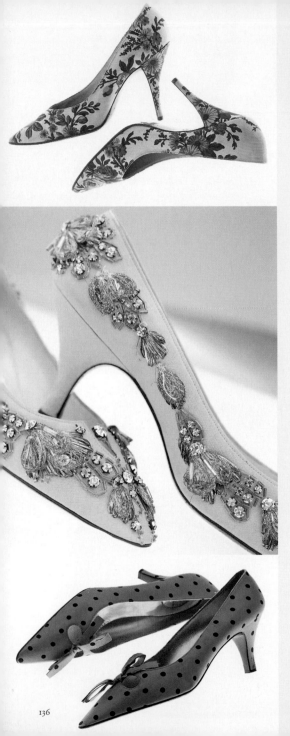

Roger Vivier, who was known as the couturier of
shoes, became independent in 1937 and started
making shoes for Dior in 1953. His unique designs
fit perfectly with elegant Dior dresses, and it was
shoes that he made that were worn during the
coronation of Queen Elizabeth II. Many famous
people, including Elizabeth II, the Duchess of
Windsor, and Elizabeth Taylor were captivated by
Vivier shoes.
Shown here are three pumps by Vivier created for
Dior. The delicate toes and heels are typical styles
of the 1950s.

Above
Roger Vivier / Christian Dior
"Versailles" Pumps
Label: Christian Dior créé par Roger Vivier RITZ
Spring/Summer 1960

White silk and cotton fabric with blue floral print,
made by Jouy.
Inv. AC7591 92-22AB

Center
Roger Vivier / Christian Dior
Pumps
Label: Christian Dior Roger Vivier
Late 1950s

Beige silk georgette with gemstones and silver
embroidery.
Inv. AC5418 86-31-2AB

Below
Roger Vivier / Christian Dior
Pumps
Label: Christian Dior créé par Roger Vivier RITZ
Late 1950s

Ice-green silk twill with black dot print, ribbon
ornamentation.
Inv. AC5419 86-31-3AB

→ Advertisement for shoes by Roger Vivier /
Christian Dior
L'Officiel, March 1960

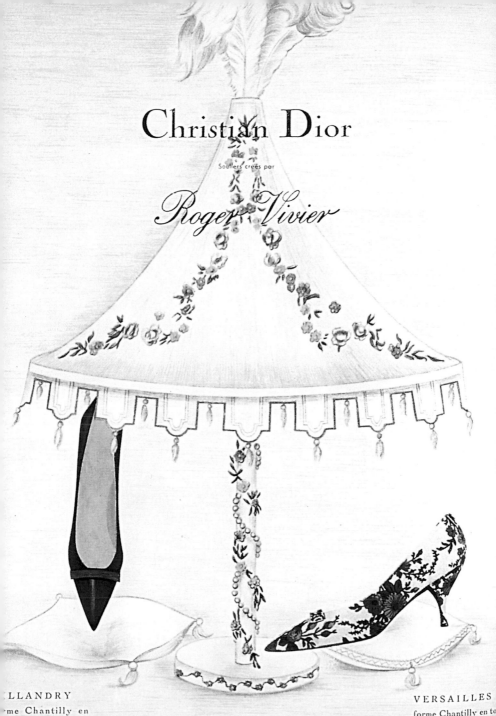

Christian Dior

Souliers créés par

Roger Vivier

LLANDRY
me Chantilly en
ravelle marine

VERSAILLES
forme Chantilly en toile
de Jouy bleu et blanc

In 1953 Dior formed a licensing department. Daimaru, a Japanese department store immediately applied for a license, and the Daimaru Dior Salon opened that same year. Dior haute couture designs were then produced in Japan. Dior continued to expand the licensing business and strengthened its foundation.
This dress was made with Japanese fabric. This is a specialized design, with a zouave skirt by Yves Saint Laurent, who took over the house in 1957. Christian Dior also often used traditional Japanese silks.

Daimaru Dior Salon
Cocktail Dress
Label: Christian Dior EXCLUSIVITE POUR LE JAPON par DAIMARU
c. 1958

Orange rayon woven with gold and silver Dacron threads, patterned with pine motif; set of bolero and dress with brassiere inside.
Inv. AC7598 92-23-6AB

Cristobal Balenciaga, the master of *haute couture*, was at the pinnacle of fashion in the 1950s. He was one of the few designers who could actually cut and sew, and he created complex forms with his cutting technique. The dress on the left has a nostalgic pannier-like line on both sides of the waist. The sharp jets at the top form a strong contrast, and shine like the teeth of a beast.

The dress on the right was made in 1962, a time when Balenciaga was experimenting with new material, plastic. Plastic had been in use since the 1920s, and was in common use in the United States by the 1950s. Well before his time, Balenciaga set about using modern shapes and materials that would later become part of the mainstream.

← **Cristobal Balenciaga**
Evening Dress
Label: BALENCIAGA 10, AVENUE
GEORGE V PARIS 89429
Autumn/Winter 1949

Black silk faille; rhinestone, bead and jet embroidery; overskirt of front and back panels.
Inv. AC2072 79-5-2

→ **Cristobal Balenciaga**
Cocktail Dress
Label: none
Autumn/Winter 1962

Black gazar with all-over black plastic paillette embroidery.
Inv. AC7006 91-15-2

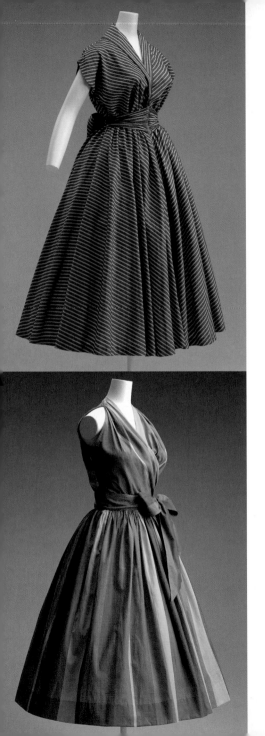

Before World War II, American fashion relied on Parisian *haute couture*, but when the war came, America had to find its own original style.

Using simple fabrics like denim and gingham that had been used for laborer's uniforms, Claire McCardell created active and simple clothing for women, and established an original American fashion. The clean-structured clothes that she created were exactly what America, with its well-organized mass-production system, had been waiting for, and ready-to-wear clothes were soon available right across the country.

↖ **Claire McCardell**
Day Dress
Label: claire mccardell clothes by townley
1940s

White, red and green striped cotton satin and cotton broadcloth; cap sleeves; wing collar; self-fabric belt.
Inv. AC9379 96-26-2AB

← **Claire McCardell**
Day Dress
Label: claire mccardell clothes by townley
1940s

Polychrome striped plain-weave cotton; bias-cut bodice; belt of the same material.
Inv. AC9452 97-16-5

→ **Claire McCardell**
Day Dress
Label: claire mccardell clothes by townley
c. 1949

Cherry-red pleated wool jersey; black leather belt with gold buckle.
Inv. AC9275 95-45-2AB

Chanel returned to the world of fashion in 1954. Despite the elegance of the 1950s, the Chanel suit, the completed form of the cardigan suit first created in the 1920s, was considered old fashioned and generally ignored; but in fact its clean lines were before its time, and it foreshadowed the ready-to-wear era that was on the way. On the left page is a wool jersey suit; on the right is one of wool tweed. This high-quality fabric is surprisingly light, and on the inside hem a chain is sewn on as weight.

← **Gabrielle Chanel**
Day Ensemble
Label: CHANEL
Late 1950s

Navy wool jersey jacket and skirt; white wool braid; wrapped buttons at cuffs.
Inv. AC4812 84-10-2AB
Gift of Fashion Institute of Technology, SUNY

→ **Gabrielle Chanel**
Day Ensemble
Label: none
c. 1966

Pink, yellow and purple plaid wool tweed; jacket and skirt; gold buttons; lining and blouse in quilted plaid silk twill.
Inv. AC383 77-13-2AC

→→ **Gabrielle Chanel**
Day Ensemble
Label: CHANEL
c. 1969

Pink, yellow and blue plaid wool tweed; jacket and skirt; gold buttons; lining and blouse in quilted plaid silk twill; detachable cuffs in the same fabric.
Inv. AC4811 84-10-1AG

Mini skirts appeared in the 1960s, when fashion started to be controlled by the younger generation. The word "mini" came from "minimum", which in fashion indi-cated skirts that showed the thighs. André Courrèges, who debuted in 1961, created the mini in 1965. With the respected position of *haute couture*, the mini skirt came to be accepted by society. A few years before that, in 1963, he introduced a pants ensemble for evening wear, and tried to revitalize the old-fashioned image of *haute couture*. Women were already wearing trousers for leisure wear, but after their acceptance by leading *maisons*, they became far more common.

← Dresses by André Courrèges
Photo: Guégan
L'Officiel, September 1967

→ **André Courrèges**
Pantsuit
Label: COURRÈGES PARIS
Autumn/Winter 1969

White cotton twill vest and pants;
gold buttons; patch pockets.
Inv. AC5713 87-46-2AB

↓ **André Courrèges**
Dress
Label: COURRÈGES PARIS
Autumn/Winter 1967

White cotton satin layered with silk
organdy with light green floral
embroidery; silk organdy at waist.
Inv. AC9101 94-7-3

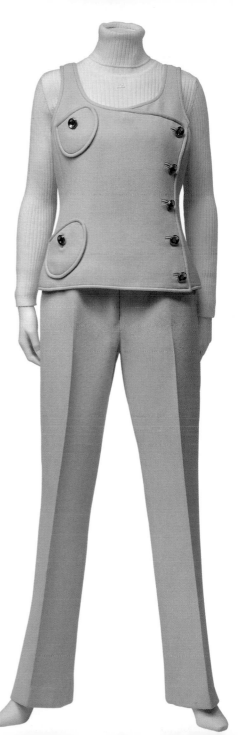

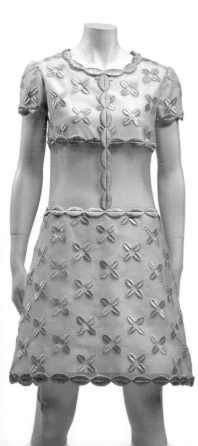

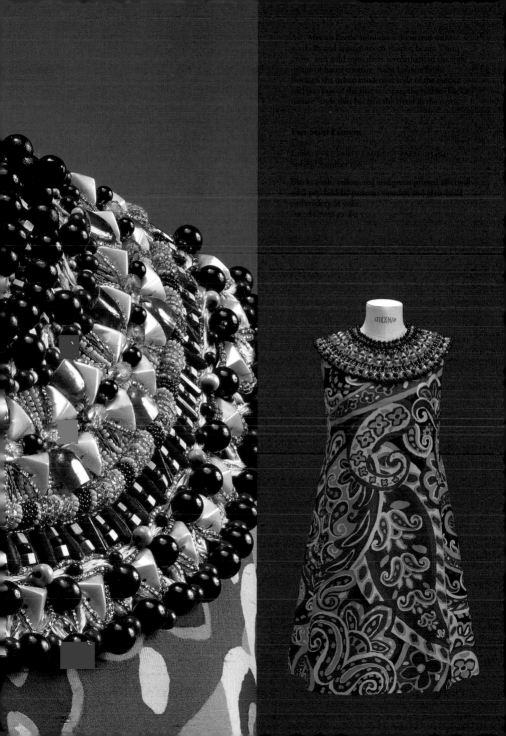

for African Look, imitating a decorated with
shells and animal tooth shaped beads. This
ethnic and wild trendwas revolutionizing the staid
image of haute couture. Saint Laurent broke
beneath the urban made ready style of the sixties
and was one of the first tolerate incorporating the ethnic
nature style that became the trend in the 1970s.

Yves Saint Laurent
Dress
Label: YVES SAINT LAURENT PARIS 014454
Spring/Summer 1967

Black, pink, yellow, red and green printed silk twill
with psychedelic patterns; wooden and glass bead
embroidery at yoke.
Inv AC7893.93-84

PIET MONDRIAN '2?

In 1965, Saint Laurent created the "Mondrian Look", and the "Pop Art Look" was presented the following year. Art became a fashion motif. With the simple forms of the 1960s, images of paintings could be applied directly to the dress. From then on, fashion took inspiration from the art styles that were popular at the time, such as Op Art and psychedelic designs, and fashion designs developed in another direction. Shown here is a dress created by Saint Laurent. It was inspired by Piet Mondrian, the father of neoplasticism, and was called the "Mondrian Look." It brought a new elegance to haute couture.

← **Piet Mondrian**
Composition with Red, Black, Blue and Yellow, 1928
Wilhelm-Hack-Museum, Ludwigshafen on the Rhine

Yves Saint Laurent
"Mondrian" Dress
Label: YVES SAINT LAURENT PARIS
Autumn/Winter 1965

White, red and black wool jersey.
Inv. AC5626 87-18-1
Gift of Mr Yves Saint Laurent

Pierre Cardin introduced the space-oriented, futuristic style in 1966. His geometric, simply designed garments were novel but also functional and in sync with the newly established *prêt-à-porter* market of the 1960s.

The two examples on the left were most likely made for American licensing. After the appearance of *prêt-à-porter* in the 1960s, the licensing business was the financial backbone that supported the *haute couture maisons*. On the right is a suit from 1966. The bias cut and precise sewing makes the shape stand out, its mini length giving it a fresh look.

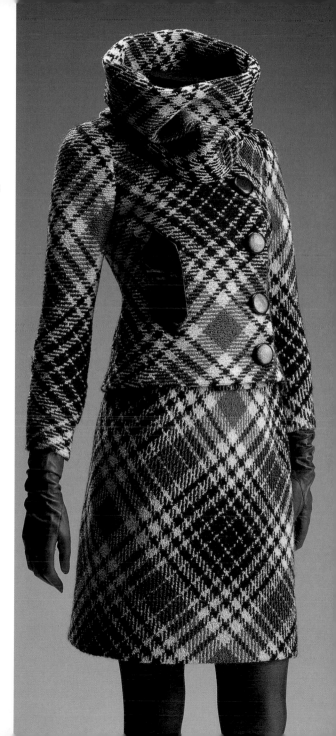

←← **Pierre Cardin**
Jumper
Label: Pierre CARDIN PARIS NEW YORK
c. 1970

Navy wool jersey with red vinyl strap.
Inv. AC10089 99-14-2

← **Pierre Cardin**
Dress
Label: Pierre CARDIN PARIS NEW YORK
c. 1968

Black wool jersey mini dress with white vinyl panel ornamentation.
Inv. AC5714 87-46-3

→ **Pierre Cardin**
Suit
Label: Pierre Cardin PARIS
Autumn/Winter 1966

Beige and black plaid wool tweed; jacket and mini skirt; large turtleneck; camel wool jersey sleeveless top.
Inv. 10090 99-40-3AD

In 1966 Paco Rabanne made his *haute couture* debut. He overturned the common belief that clothes had to use thread and fabric, and shocked many with his use of new materials like plastic as fabric.

↓ **Paco Rabanne**
Dress
Label: none
Spring/Summer 1969

Mini-dress of chrome-plated plastic and steel disks linked by stainless steel rings.
Inv. AC6755 90-19-4

→ **Paco Rabanne**
Top
Label: none
c. 1969

Pink and white plastic disks and white beads linked by stainless steel rings.
Inv. AC6753 90-19-2

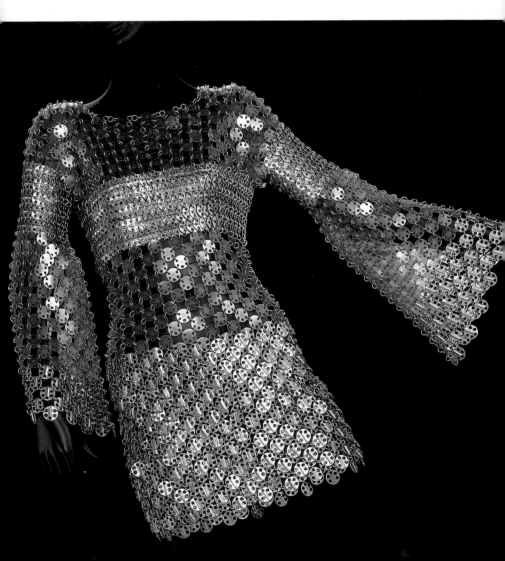

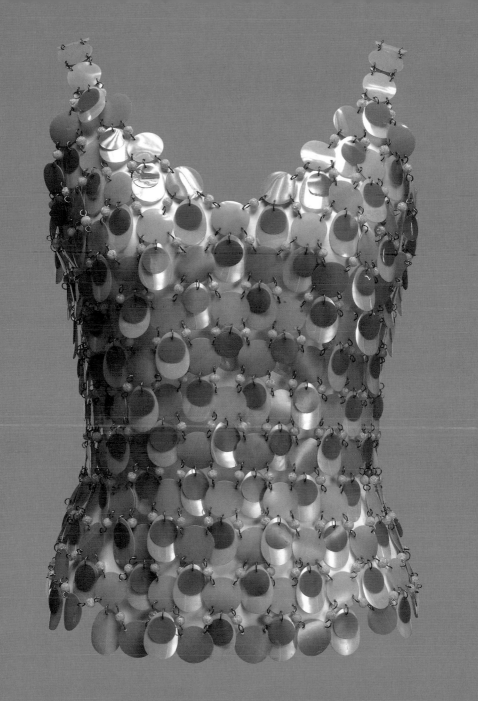

In 1962, when Andy Warhol had his first exhibition, *32 Soup Cans* was one of the paintings that was revealed to the world. Pop Art, which was art made with imagery of the mass-production era that could be found anywhere, grabbed the attention of the masses.

The paper dress shown here is a dress that ties in well with Pop Art, symbolizing the 1960s culture of consumption. Warhol himself made the "banana dress" and the "fragile dress" in 1966.

→ **Anonymous**
"Souper Dress" Paper Dress
Label: Souper Dress
c. 1966
American

"Campbell's Soup" can-motif printed non-woven mini dress with black bias tape.
Inv. AC9561 98-14-2

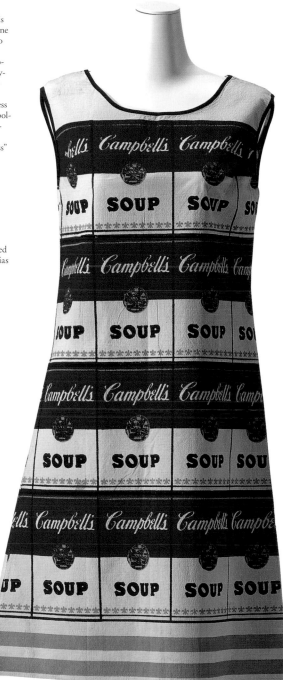

Rudi Gernreich, who was active in America, created the topless swimsuit in 1964, and in 1965 made the thin skin-colored nylon brassiere known as the "No Bra." These sprang the new concept of "body-consciousness" on the unsuspecting world.

On the left is the "mono-kini", the topless bathing suit that caused a scandal. On the right is a bathing suit with crossing black straps. This showed the novel idea that the skin itself could become a beautiful garment.

→ **Rudi Gernreich**
Topless Swimsuit
Label: RUDI GERNREICH DESIGN
FOR HARMON KNITWEAR
1964

Black and taupe striped wool jersey; strap-only top.
Inv. AC10127 99-27

→→ **Rudi Gernreich**
Swimsuit
Label: RUDI GERNREICH DESIGN
FOR HARMON KNITWEAR
1971

Black and taupe wool jersey with black strap.
Inv. AC9560 98-14-1

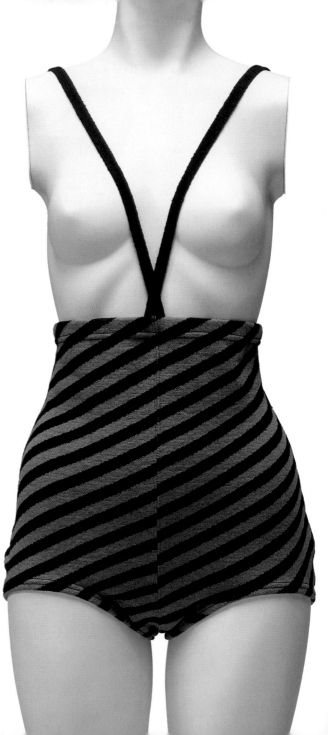

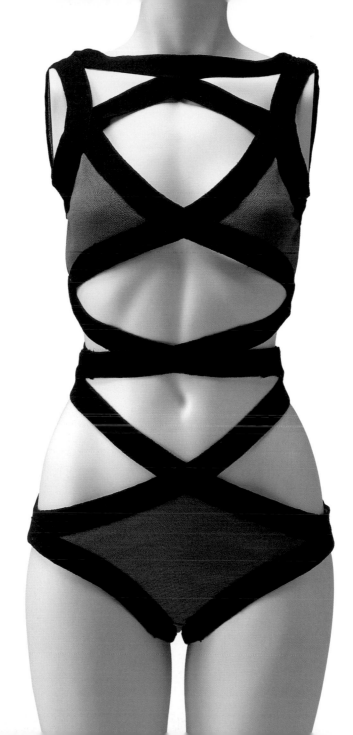

In the late 1960s, protest against the Vietnam War started to spread. Hippies abandoned the values of modern society, and empathized with non-Western cultures and religions. Both men and women grew their hair long and wore a hand-made type of fashion which became popular with younger generations around the world. Designers in Paris did not fail to pick up on these street fashions, and the trends made their way into Paris designs as folkloric fashion and patch-work-designed jeans.

Page 161, left
Emmanuelle Khanh
Smock
Label: Emmanuelle Khanh diffusion
Froisa Paris
Spring/Summer 1971

White cotton gauze with polychrome scenic cotton embroidery near square neck; floral and butterfly-motif embroidery.
Inv. AC7781 93-22-5
Gift of Ms. Yoshiko Okamura

Levi's
Jeans
Label: Levi's
c.1971

Deep- and light-color blue denim patchwork bell-bottoms.
Inv. AC9758 99-1-5

Page 161, right above
Left: **Thea Porter**
Dress
Label: thea porter london
c. 1970

Yellow ground with red stripe Indian cotton; orange cotton with mirror work at front; blue velvet ribbon.
Inv. AC9749 98-43-10

Right: **Barbara Hulanicki / BIBA**
Dress
Label: BIBA
Early 1970s

Beige-pink wool; floral print; large square neck; matching belt.
Inv. AC10414 2000-48-1

Page 161, right below
Left: **Giorgio Sant'Angelo**
Tunic and Pants
Label: SANT'ANGELO
c.1970

Red tricot tunic with purple and orange turtleneck and cuffs, long tie with fringe; red polyester tricot pants.
Inv. AC9731 98-38-1, AC9742 98-43-3

Right: **Stephen Burrows**
Tunic and Pants
Label: stephen burrows
Early 1970s

Green tricot bodice and light yellow sleeves; red stitching at hem and cuff.
Inv. AC9740 98-43-1AB

↓ Singer Joan Baez and actress Vanessa Redgrave at a demonstration against the Vietnam War, 1965.

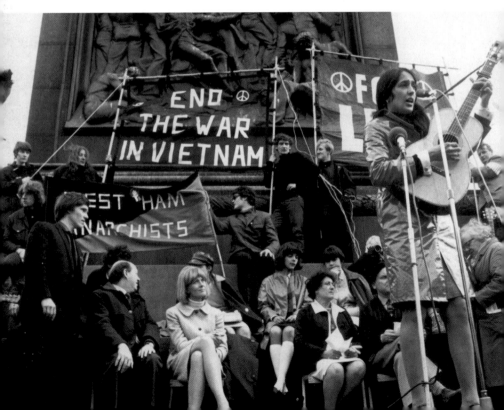

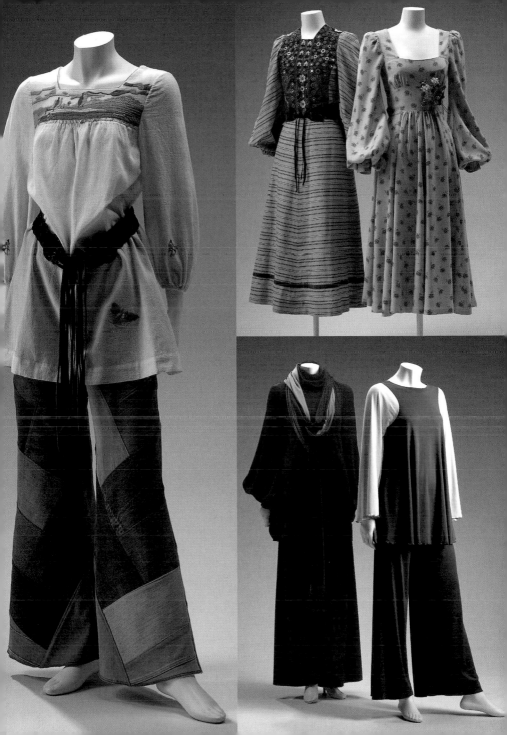

In the two bodices shown here, McQueen pressed leather and Miyake converted plastic into a realistic second skin. Their new way of looking at the human body as the basis of clothing is very apparent here.

← **Alexander McQueen / Givenchy**
Bodice and Pants
Label: GIVENCHY COUTURE
Autumn/Winter 1999

Red pressed-leather bodice; white leather pants.
Inv. AC10105 99-17AB

↓ **Issey Miyake**
Bodice
Label: none
Autumn/Winter 1980

Red plastic bodice; embossed inside.
Inv. AC5643 87-25A
Gift of Miyake Design Studio

These two examples both show Western culture's ways of creating a style that solves the problem of fitting the body for the ideal shape. One way of forming the ideal shape is stretch fabric; the other is the traditional *haute couture* style.

On the left is a suit by Galliano, from London. He became the designer for Dior in 1996, and takes his inspiration from historical and ethnic garments to create the modern styles of today.

On the right is a dress made by Alaïa. Lycra, created by DuPont in 1958, developed through the years to gain a high-quality elasticity.

← **John Galliano / Christian Dior**
Suit and Choker
Label: Christian Dior HAUTE COU-
TURE AH97 PARIS 29374
Autumn/Winter 1997

Set of jacket and skirt of gray wool
tweed; pad at jacket hem; train with
long skirt; choker of 35 rings of two-
toned silver.
Inv. AC9559 98-13AC

→ **Azzedine Alaïa**
Dress
Label: ALAÏA PARIS
1985–1989

Navy rayon lycra; large v-cut at back;
seam line and pleats at hem.
Inv. AC9744 98-43-5

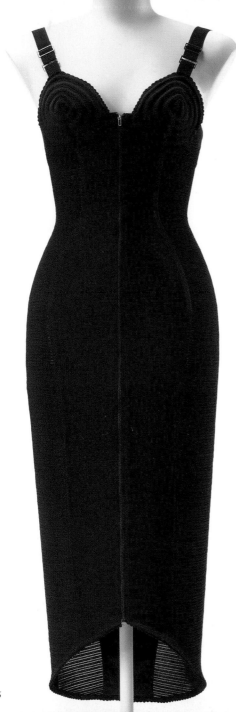

Gaultier debuted in 1976. He loved parody, and in the 1980s took what had traditionally been undergarments, such as the corset and girdle, and transformed them into active outerwear for women, obliterating the negative image of underwear. The transformation of underwear into outerwear is a major phenomenon of the late twentieth century, originating in the body-conscious movement of the 1980s that emphasized the beauty of a fit, healthy body.

Jean-Paul Gaultier
Dress
Label: Jean-Paul GAULTIER pour GIBO
Spring/Summer 1987

Red silk satin, nylon and lycra mixed; transparent elastic nylon section from side to back.
Inv. AC5640 87-24-3

→ Gaultier's dress from Spring/Summer 1987

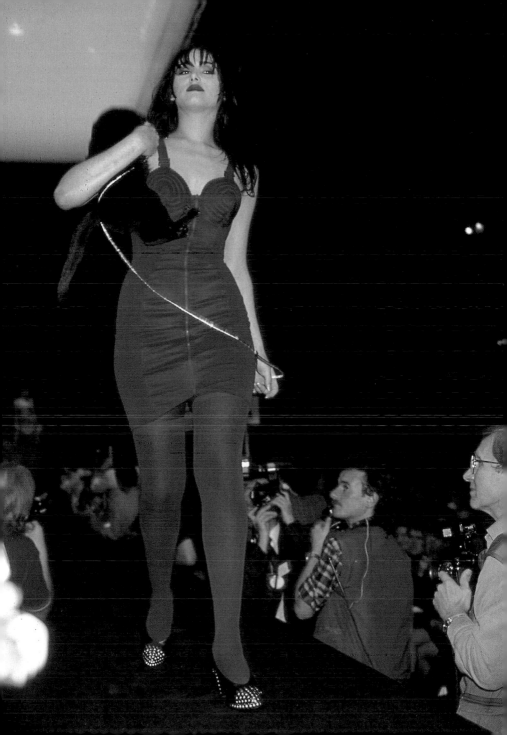

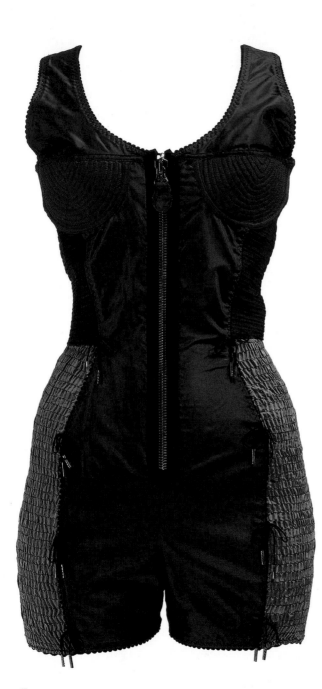

Gaultier designs by using images from the arts and music. In the collection shown here, he took his inspiration from the work of the American artist Richard Lindner. Lindner used women wearing corsets in his art to express mixed female emotions of aggression and restraint.

← **Jean-Paul Gaultier**
Jump Suit
Label: Jean-Paul GAULTIER
Spring/Summer 1990

Blue, green, orange and golden-brown striped taffeta, lycra, elastic shirring, black ribbon and zipper.
Inv. AC8949 93-34

Westwood became known as the Queen of Punk, and started the Vivienne Westwood brand in 1983. After spending time in Paris, she returned to London in 1987 and used underwear of the past such as corsets, crinolines, and bustles as outerwear, and together with Gaultier expressed a new style of femininity.
Shown here is a top that resembles a bodice and a short pair of pants. This unbalanced match of classic underwear with metallic zippers is a typical Westwood design.

→ **Vivienne Westwood**
Jacket, Bodice, Short Pants, Pants and Garters
Label: Vivienne Westwood London
Autumn/Winter 1997

Metallic beige synthetic jacket, bodice and short pants; boned stretch knit at bodice's side, bodice attachable to jacket by two zippers.
Inv. AC9717 98-33AE

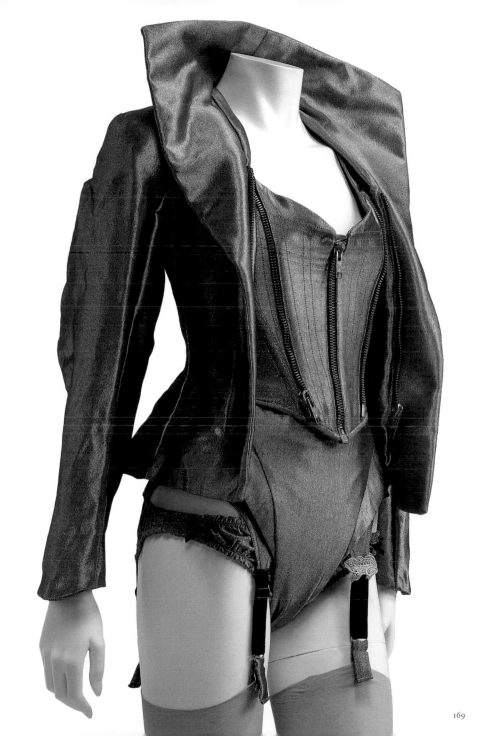

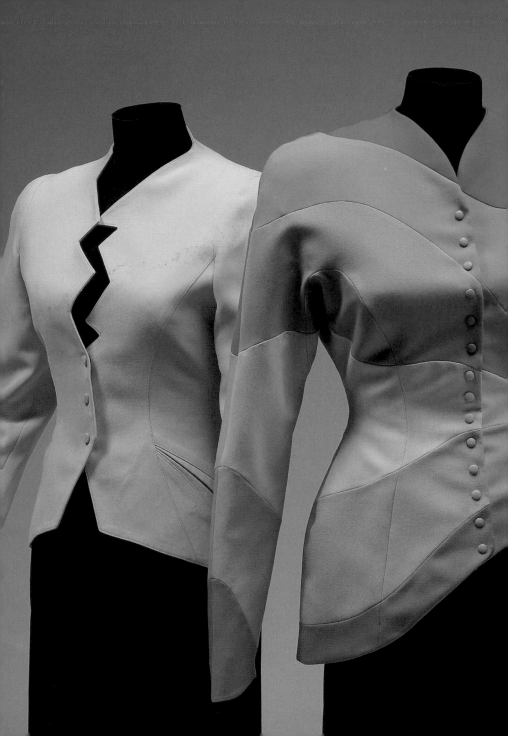

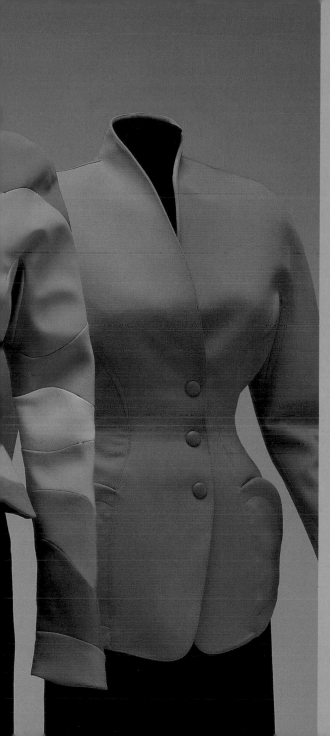

Thierry Mugler debuted in 1973, and is one of the major forces in "power dressing." The sexy and powerful designs help define the perfect image of a woman. The thick shoulder padding typical of the 1980s gives a sharp, downward triangular silhouette.

Left
Thierry Mugler
Jacket
Label: Thierry Mugler PARIS
Autumn/Winter 1988

Yellow polyester-triacetate mix; zigzag cutting at hem; slanted sleeve cuffs.
Inv. AC10151 99-30-14A
Gift of Ms Sumiyo Koyama

Center
Thierry Mugler
Jacket
Label: Thierry Mugler PARIS
Spring/Summer 1990

Eight-colored wool gabardine patchwork; five colored snaps at front; oblique cut at right hem.
Inv. AC10155 99-30-18
Gift of Ms Sumiyo Koyama

Right
Thierry Mugler
Jacket
Label: Thierry Mugler PARIS
Late 1980s

Salmon-pink wool gabardine; high neck.
Inv. AC10153 99-30-16
Gift of Ms Sumiyo Koyama

Romeo Gigli debuted in Milan in
1983. He eliminated the thick shoul-
der padding of that time, and created
a silhouette with soft rounded shoul-
der lines.
The cocoon silhouette was another
feature of his works. This full-bodied
coat looks light because of its lacy knit
fabric.

Romeo Gigli
Coat
Label: ROMEO GIGLI
Spring/Summer 1991

Black raffia lacy knit coat with hood.
Inv. AC10196 99-36-7

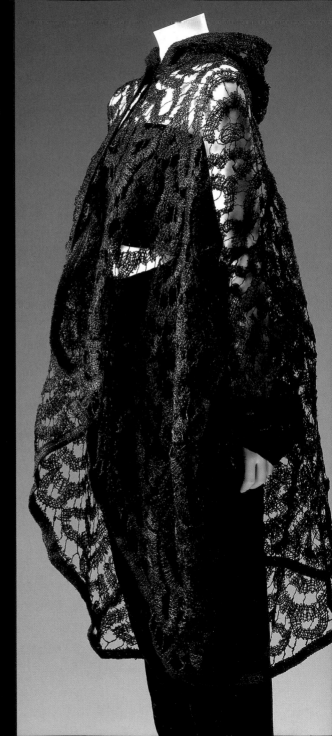

→ **Christian Lacroix**
Bolero and Dress
Label: CHRISTIAN LACROIX prêt-a-
porter
c. 1990

Bolero of purple silk satin jacquard
woven with black floral pattern; silk
taffeta frill; dress of purple silk print-
ed with angel, animal and plant pat-
tern.
Inv. AC9605 98-16-43AB
Gift of Ms Mari Yoshimura

↘ **Vivienne Westwood**
Top and Skirt
Label: none
Spring/Summer 1986

Pink cotton jersey top with dot print;
gray rayon satin skirt with three hoops
inside; frilled hem; draw strings.
Inv. AC5486 86-46-1, AC5487 86-46-2

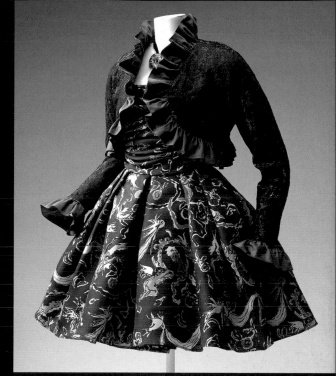

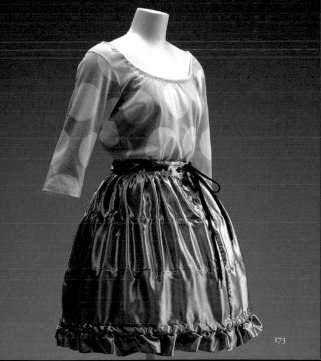

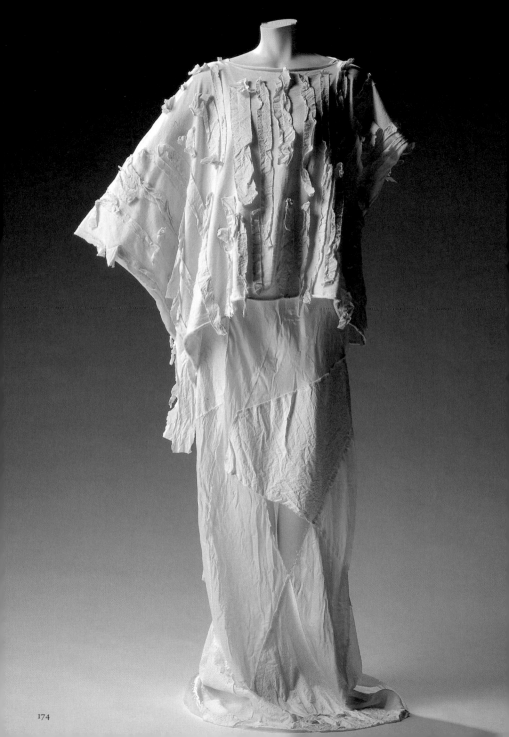

In October, 1982, Kawakubo and Yamamoto held their second Paris *prêt-à-porter* show. The style that debuted that year was colorless, rag-like, and full of holes, which promoted shabby clothing. Their collection created a new vocabulary in fashion: the "*boro* look", "beggar look", and the "ragged look". The designs expressed a Japanese concept of beauty, the beauty of conscious destitution. Their collection shook up the concept of Western-style clothing, and threw the Parisian fashion world into controversy. The world was shocked, because Japanese designers had proved that there was a possibility that clothes accepted worldwide could come from cultures other than that of Western Europe.

‹ **Rei Kawakubo / Comme des Garçons**
Blouse and Dress
Label: COMME des GARÇONS
Spring/Summer 1983

Off-white cotton jersey blouse with cotton ribbon appliqué; washed white patchwork dress of sheeting and rayon satin.
Inv. AC7801 93-24-9AB
Gift of Comme des Garçons Co., Ltd.

→ **Yohji Yamamoto**
Jacket, Dress and Pants
Label: Yohji Yamamoto
Spring/Summer 1983

White cotton cut-work jacket, dress and pants.
Inv. AC7755 93-15B,E, AC8984 93-42-8
Jacket and Pants: Gift of Mr Hiroshi Tanaka; Dress: Gift of Ms Sumiyo Koyama

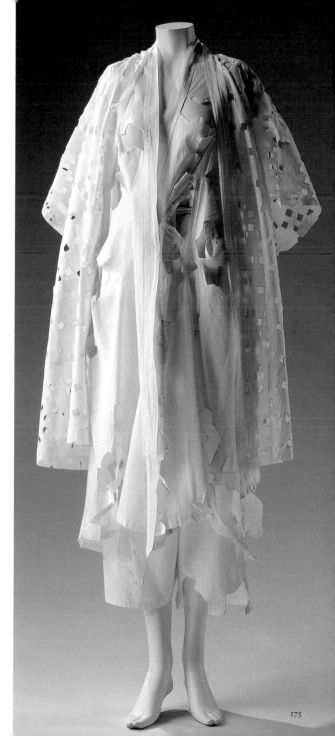

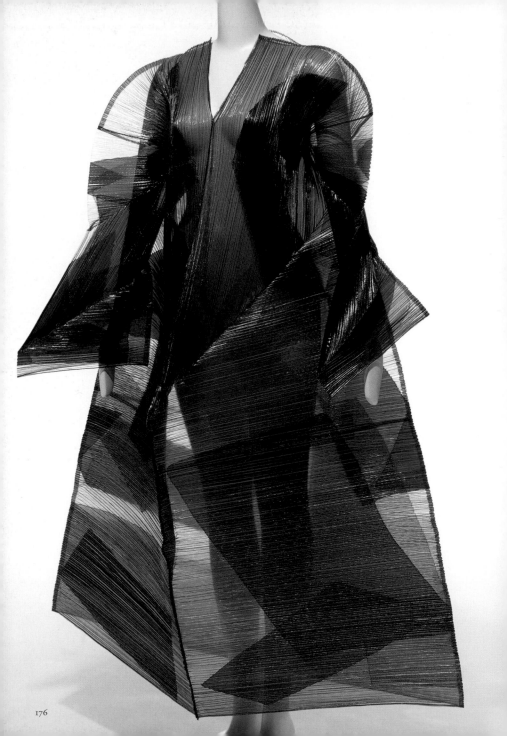

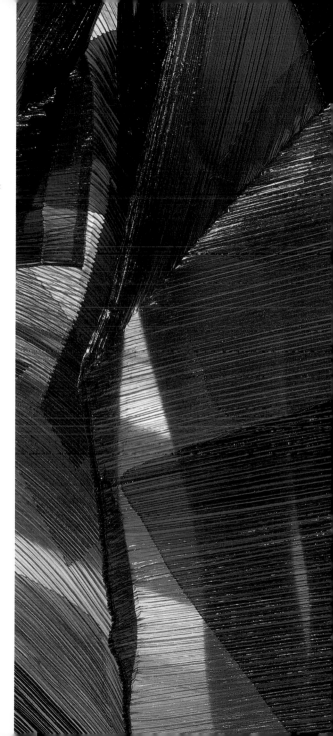

In 1976 Miyake presented the flat "a piece of cloth" design, which is in many ways the basic concept behind Japanese clothes. In the late 1980s, Miyake developed this concept in his pleated ensembles. He made the pieces contrary to the standard style, sewing the outfit first, then putting the pleats on afterwards. By the use of all the characteristics of polyester, the shape and the function combined organically and gave birth to a new type of clothing.

Shown here is a coat created by this innovative technique, with a form that looks like a stage costume for a traditional Japanese *No* dance.

Issey Miyake
Coat
Label: ISSEY MIYAKE
Spring/Summer1995

Clear-pink pleated polyester mono-filament appliquéd with red, blue and green pieces.
Inv. AC9214 95-10-2

In 1998, Miyake became interested in tubular knits, and started research on how to apply the functional features of knits. Miyake's determination led to the mixture of knitting and contemporary innovative technology, which culminated in the birth of "A-POC."

As shown here, the top is a cylindrically knitted piece. A long knit cylinder is folded at the shoulders, pulled down to the waist, and covers over the arms. The design that locks the arm stands out, because it goes against all the functional features of a knit, such as lightness, resistance to wrinkles, and adaptability to any shape.

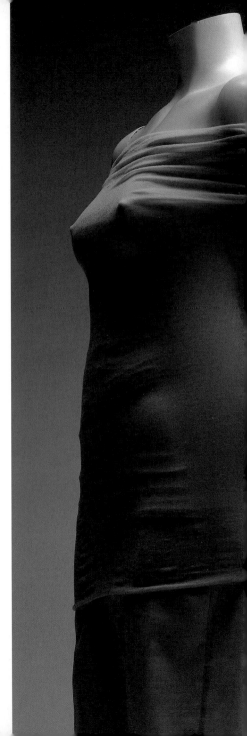

Issey Miyake
Dress
Label: ISSEY MIYAKE
Spring/Summer 1998

→ Beige woolly nylon knit one-piece dress; cotton and silk mix skirt.

→→ Beige-pink woolly nylon knit one-piece dress; cotton and silk mix underdress.
Inv. AC9552 98-12-2, AC9553 98-12-3

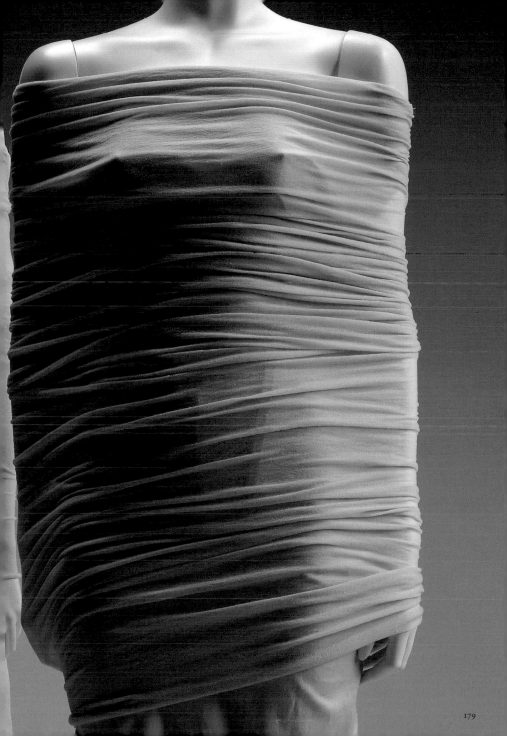

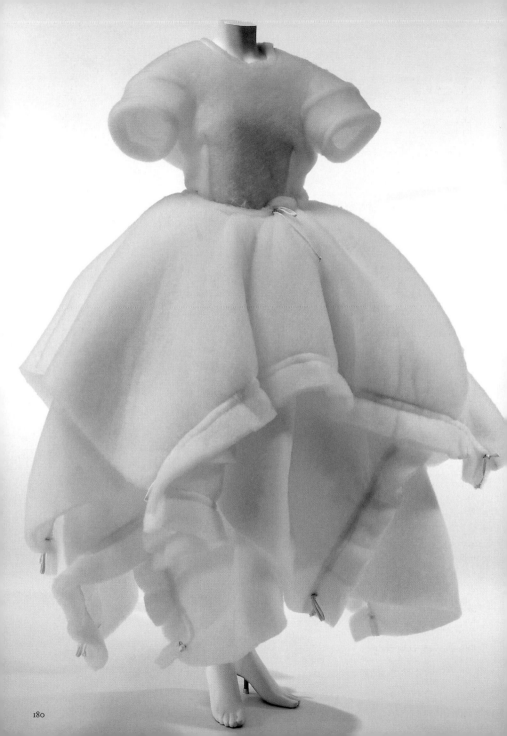

High-tech fabric combined with a shape that resembles the crinoline style. The common belief that chemical means artificial is overturned, and the piece makes a soft and warm impression.

On the right is an outfit that resembles the bustle, which was a nineteenth-century undergarment that put emphasis on the back. Kawakubo is trying to express the dissonance between the body and the form of the outfit.

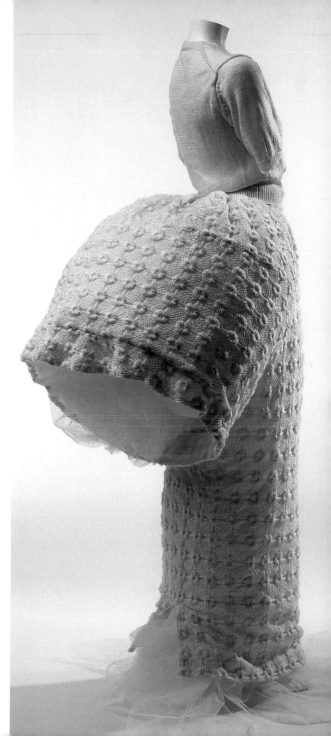

← **Rei Kawakubo / Comme des Garçons**
Wedding Dress
Label: COMME des GARÇONS
Autumn/Winter 1990

White non-woven fabric one-piece dress with ribbon around hem; petticoat in the same material.
Inv. AC6778 90-22AB
Gift of Comme des Garçons Co., Ltd.

→ **Rei Kawakubo / Comme des Garçons**
Sweater and Skirt
Label: COMME des GARÇONS NOIR
Autumn/Winter 1995

Baby-pink acrylic knit sweater; matching long skirt with embroidery; bustle-like tube sewn to back of skirt; tulle petticoat.
Inv. AC9273 95-44-2AC

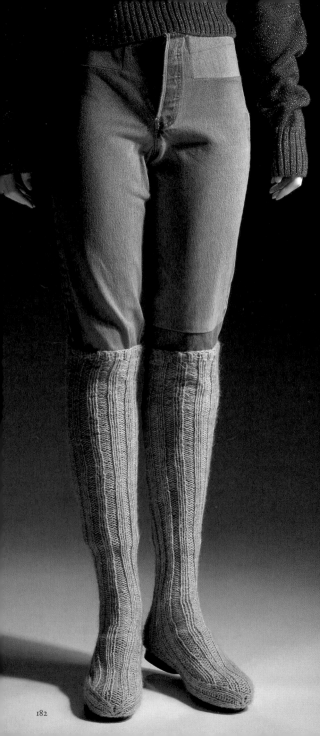

In the 1990s vintage clothes and remade clothes grabbed the center stage on the fashion scene, and new products that had a vintage look were the must-have items of the year. On the left is a Margiela shoe cover. The cover can be taken off and is washable. When the cover is taken off the surface of the shoe looks brand new, and when the cover is put back on, a new feeling toward the shoe can be experienced. This brought back the feeling that something should be used carefully over a long period. On the far right is a denim skirt that was intentionally made to look as if it had been worn for a long time.

← **Martin Margiela**
Sweater, Jeans, Slip-Ons and Shoe Covers
Label: (white cotton tape)
Autumn/Winter 1999

Pinkish purple lamé knit sweater; patched jeans; black leather slip-on shoes; wool knit shoe covers.
Inv. AC10189 99-35-2AB, D-H

→ **Tom Ford / Gucci**
Sweater and Skirt
Label: GUCCI
Spring/Summer 1999

Yellow knit sweater; denim skirt with floral embroidery of silk and sequins.
Inv. AC9752 98-46AB

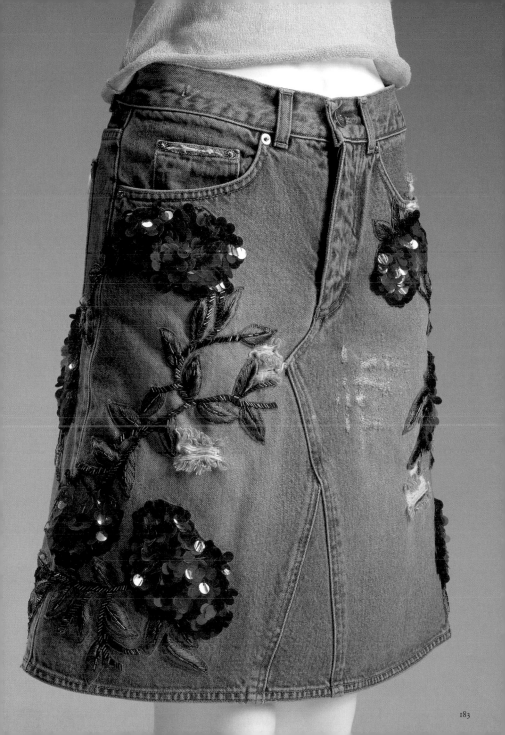

Fashion designers continue to search for varied shapes in fashionable clothing. At the end of the twentieth century, the development of new technologies allowed new shaping methods to be attempted.

On the left, the shape of the dress is determined by the inserted wire. The spiral-shaped wire leads the fabric to create a unique and lively form.

On the right is a skirt that forms a wavy shape, created out of a synthetic fabric with plastic woven into it.

← **Junya Watanabe**
Dress and Skirt
Label: JUNYA WATANABE COMME des GARÇONS
Autumn/Winter 1998

White cotton shirt-dress; skirt of green wool serge, wired inside.
Inv. AC9689 98-18-5AB

→ **Yohji Yamamoto**
Dress
Label: Yohji Yamamoto
Spring/Summer 1999

White polyester printed with gray stripes; quilted.
Inv. AC9739 98-42-3AB
Gift of Yohji Yamamoto Inc.

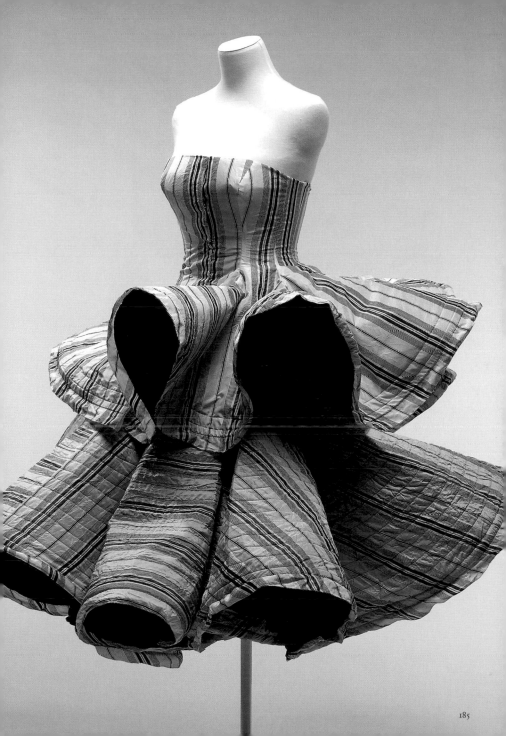

After his Paris debut with asymmetrical clothes using hanging fabric, Yamamoto returned to a more traditional Western dressmaking style in the mid-1980s.

The felt dress on the right has a close resemblance to a nostalgic form based on historical costumes. Through its exaggeration of the back and hips, this dress is trying to create a new recognition of the human body.

Yohji Yamamoto
Dress
Label: Yohji Yamamoto
Autumn/Winter 1996

Black and white felt; black knit under skirt.
Inv. AC9328 96-13-2AB

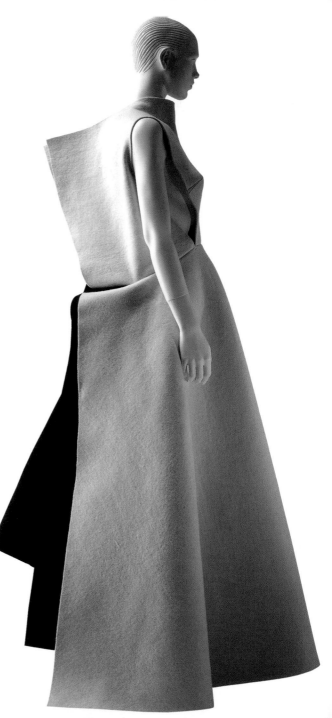

Wooden parts and hinges, materials
normally far removed from clothing,
were used in this piece. It seems as if it
is trying to escape from the human
body, which will always remain the
same. This outfit resembles the cos-
tume for the role of the manager in
Parade, a ballet performed by the Bal-
lets Russes in 1917. Pablo Picasso
designed the costumes.

Yohji Yamamoto
Vest and Skirt
Label: Yohji Yamamoto
Autumn/Winter 1991

Set of wooden vest and skirt; black
wool pieces; jointed with hinges.
Inv. AC9723 98-37-1AL
Gift of Yohji Yamamoto Inc.

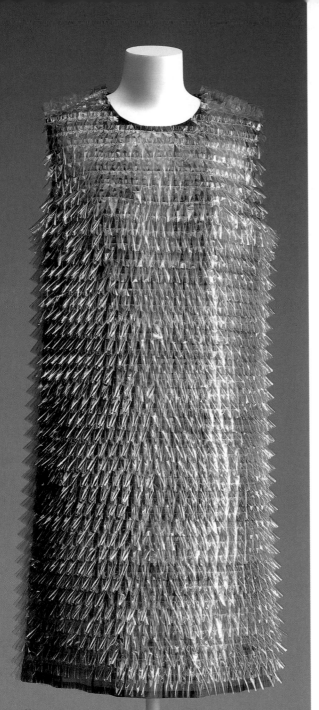

In spring/summer 2000, Watanabe used Japan's leading hi-tech fabric: the super-light, water-resistant microfiber. A wearer of this dress can even run through the city in the rain. On the right is an outfit made with many layers of ultra-light synthetic fabric. The skirt, which spreads out like a beehive, can be folded flat.

← **Junya Watanabe**
Dress
Label: JUNYA WATANABE COMME des GARÇONS
Spring/Summer 2000

Polyester printed with orange, gray and brown plaid pattern; sewn with tucked clear film all over; matching hood.
Inv. AC10284 2000-6-15

→ **Junya Watanabe**
Jacket and skirt
Label: JUNYA WATANABE COMME des GARÇONS
Autumn/Winter 2000

Red polyester jacket; yellow polyester skirt.
Inv. AC10362 2000-31-9AC

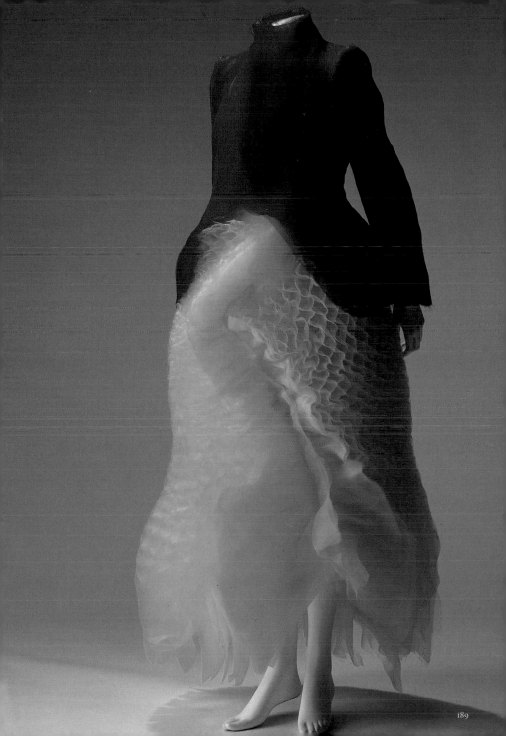

Index of Names

Renoir, Pierre-Auguste, 47
Robinson Ltd., Peter, 68
Rodrigues, N., 73
Rousseau, Jean-Jacques, 10
Rykiel, Sonia, 131

S
Saint Laurent, Yves, 130, 131, 138, 148,
149, 151
Sant' Angelo, Giorgio, 161
Satsuma, 83
Schiaparelli, Elsa, 93, 122, 123, 130
Schiel, Marthe, 127
Seurat, Georges, 45
Singer, Isaak Merrit, Earl, 46
Spencer, George John, Earl, 56
Steichen, Edward, 94

T
Takada, Kenzo, 131, 132
Taylor, Elisabeth, 136
Thatcher, Margaret, 131
Thayaht, 111
Thomson's, 76, 78
Tissot, James, 71
Troy, Jean-François de, 7

V
Vais, Mario Nunes, 98
Versace, Gianni, 131
Victoria, Queen of England,
Empress of India, 47
Vigée-Lebrun, Elisabeth, 42
Vionnet, Madeleine, 92, 93, 110, 111,
119
Vivier, Roger, 136, 137

W
Warhol, Andy, 157
Watanabe, Junya, 132, 184, 188, 189
Watteau, Jean-Antoine, 7, 9
Westwood, Vivienne, 132, 168, 169,
173
Wiener Werkstätte, 91
Worth, Charles Frederick, 44, 46,
90, 101, 130

Y
Yamamoto, Yohji, 132, 175, 185, 186,
187

Photo Credits

The editor and the publisher have made every effort to ensure that all copyrights were respected for the works illustrated and that the necessary permission was obtained from the artists, their heirs, representatives or estates. Given the large number of artists involved, this was not possible in every case, in spite of intensive research. Should any claims remain outstanding, the copyright holders or their representatives are requested to contact the publisher.

t = top, b = bottom, c = center, l = left, r = right, tl = top left, tr = top right, bl = bottom left, br = bottom right